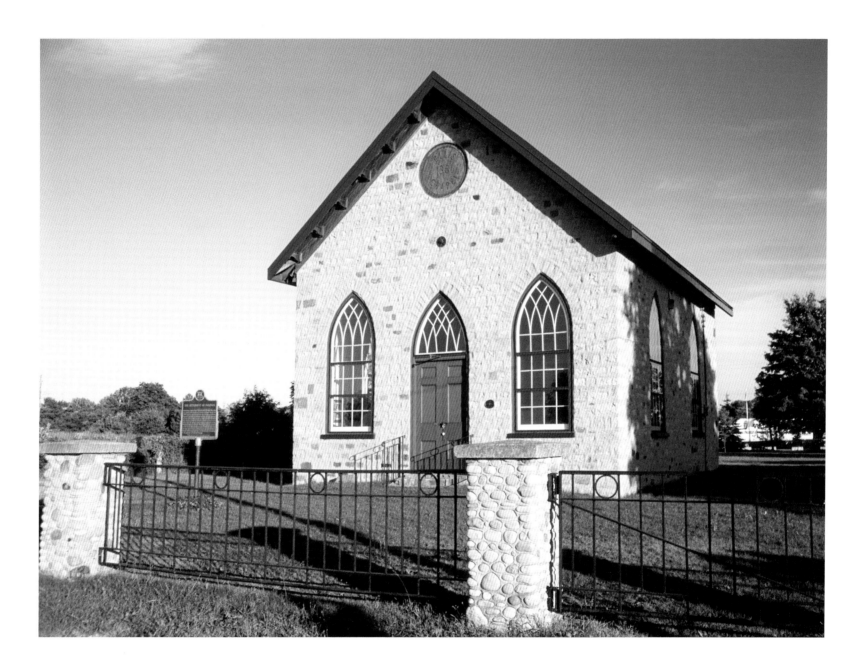

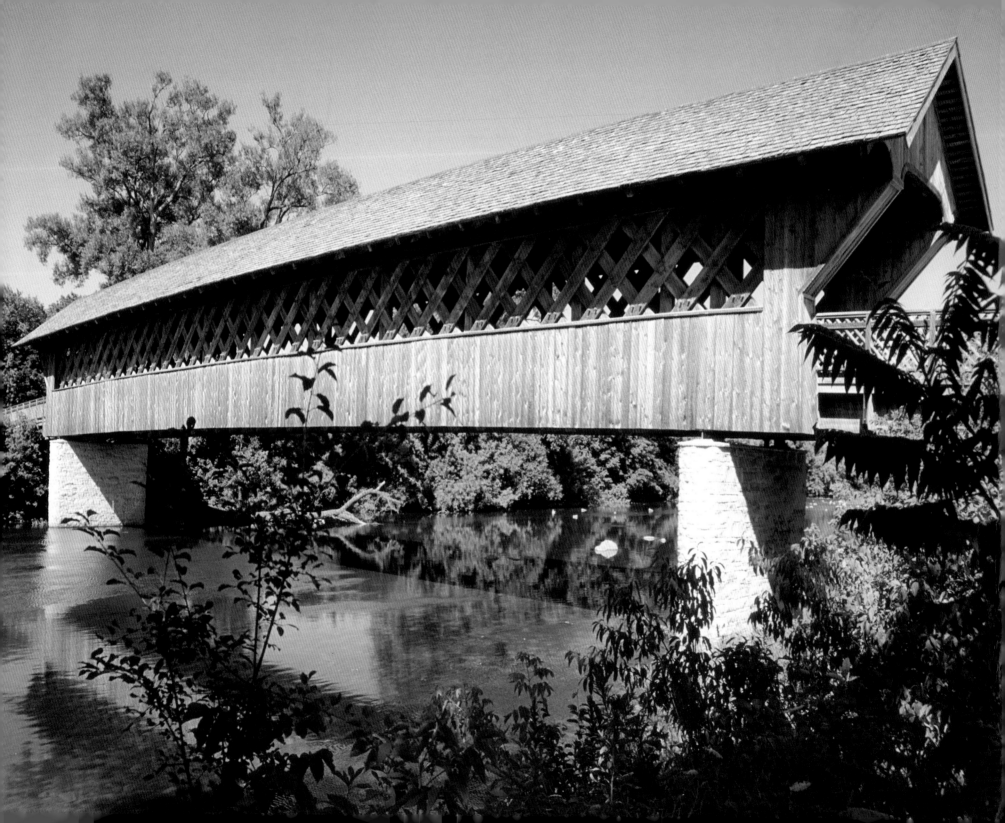

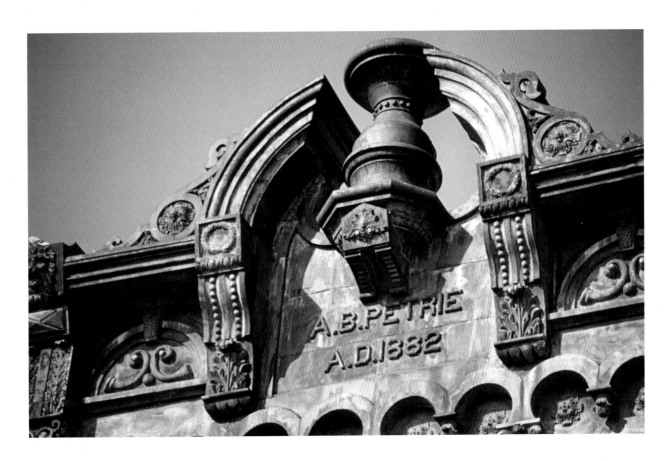

Wellington County

Fred Dahms

The BOSTON
MILLS PRESS

A BOSTON MILLS PRESS BOOK

© Fred Dahms, 2008

First printing

The publisher gratefully acknowledges for the financial support of our publishing program the Canada Council, the Ontario Arts Council, and the Government of Canada through the Book Publishing Industry Development Program (BPIDP).

Library and Archives Canada Cataloguing in Publication

Dahms, Fred, 1935–
Wellington County / Fred Dahms.
Includes bibliographical references and index.
ISBN 978-1-55046-502-0
1. Wellington (Ont. : County) — History. I. Title.
FC3095.W42D34 2008 971.3'42 C2007-907302-6

Publisher Cataloging-in-Publication Data (U.S.)

Dahms, Fred, 1935–
Wellington County / Fred Dahms.
[160] p. : col. photos., maps ; cm.
Includes bibliographical references and index.
Summary: The natural and human history and modern-day communities of Wellington County, Ontario.
ISBN: 978-1-55046-502-0
1. Wellington (Ont. : County) — History. 2. Natural history — Wellington (Ont. : County).
I. Title.
971.342 dc22 F1059.W37.D346 2008

Published in 2008 by Boston Mills Press
132 Main Street,
Erin, Ontario N0B 1T0
Tel 519-833-2407
Fax 519-833-2195
www.bostonmillspress.com
Editor: Kathleen Fraser
Design: Tinge Design Studio
Printed in China

In Canada:
Distributed by Firefly Books Ltd.
66 Leek Crescent
Richmond Hill, Ontario, Canada L4B 1H1

In the United States:
Distributed by Firefly Books (U.S.) Inc.
P.O. Box 1338, Ellicott Staion
Buffalo, New York 14205

Photo Credits

Pages 98, 99: Elora Festival, by Sophie Hogan Photography Elora.
Page 134: *Guelph Carousel*, by Ken Danby.
Page 136: Ken Danby, by Greg McKee, Ken Danby Studios.
Pages 142, 144: Art by Paul Morin.

Map Sources

County of Wellington, Visitor's Map. Guelph: County of Wellington, 2002.

Dahms, F.A. "How Ontario's Guelph District Developed." *Canadian Geographical Journal* 94, 48–55, 1977.

_____. "The Evolution of Settlement Systems: A Canadian Example, 1851–1970." *Journal of Urban History* 7, 169–204, 1980.

Historical Atlas of the County of Wellington Ontario. Toronto: Historical Atlas Publishing Co., 1906.

Historical Atlas of Waterloo and Wellington County. Toronto: Walker and Miles, 1877.

PAGE 1: Ellis Chapel, Puslinch Township.
PAGE 2: Guelph covered bridge.
PAGE 3: Iron facade of the Petrie Building, Guelph, completed in 1882.

FRONT COVER CLOCKWISE FROM TOP LEFT:
Guelph covered bridge.
Two-Bay stone slit barn, Elora Road.
Harvest on Highway 6.
Monkland Mills, Fergus.

REAR FLAP: Fred Dahms at Rockwood Number 1 Cave.

SPINE: Path to the war memorial at the John McCrae House, Guelph.

BACK COVER FROM LEFT TO RIGHT:
The Elora Mill; Church of Our Lady, Guelph; Royal City Park, Guelph.

Contents

Acknowledgments

MANY INDIVIDUALS CONTRIBUTED to the production of this volume. Without their encouragement, assistance and cooperation, it would not have been possible.

Jennifer Hedges has been a meticulous and extremely efficient editor. From the inception of this project, managing editor Noel Hudson and publisher John Denison have given me the freedom to be creative, along with expert and helpful advice on organization and content. Senior editor Kathleen Fraser and designer Christine Merlin have done a superb job of layout and design.

The following were generous with their time and information: Rosalinde Baumgartner, Donald and Joyce Blyth, Ken Danby, Tiffany Horrocks, Greg McKee, Paul Morin, Judith Nasby, Bernie and Martha Schatti, Jessica Steinhäuser, John and Marcia Stevers, Jerry Trochta and Hock Wee. I am indebted to them all. Many thanks to Dave McKee for his photographic flights over the county. I am indebted to Joe Carbone, Wellington County Planning Department, for providing the map of contemporary Wellington County.

A number of friends and colleagues in the Department of Geography at the University of Guelph were of great assistance. Julius Mage helped to edit the chapter on agriculture and was my navigator, spotter and companion on photographic trips around the county. Phil Keddie spent many hours discussing agriculture and correcting errors in my chapter on the topic. Without his advice I would not have been able to produce an accurate account of this important rural enterprise. Marie Puddister produced the historic Wellington County map. I thank them all for their interest and valuable contributions to this volume.

My daughter Tanya is an excellent professor and biophysicist, and a superb editor. She spent many hours making suggestions on style and content that greatly improved this book. As a result, my explanations of geographical phenomena are now much clearer, and my discussion of the stewardship of resources in Wellington County has been enriched.

Finally and most important, I owe a major debt of gratitude to my wife, Ruth. She has been a constant source of advice and encouragement. Whenever I was struggling with a chapter or had "writer's block," she came to the rescue. Her artistic talents were indispensable when she helped me to select subjects to photograph and images worthy of publication. Without her love and support this book would never have been completed. Thanks, Ruth!

I appreciate and acknowledge everyone who contributed to this volume, but any errors or omissions are mine alone.

Late afternoon on Puslinch Lake.

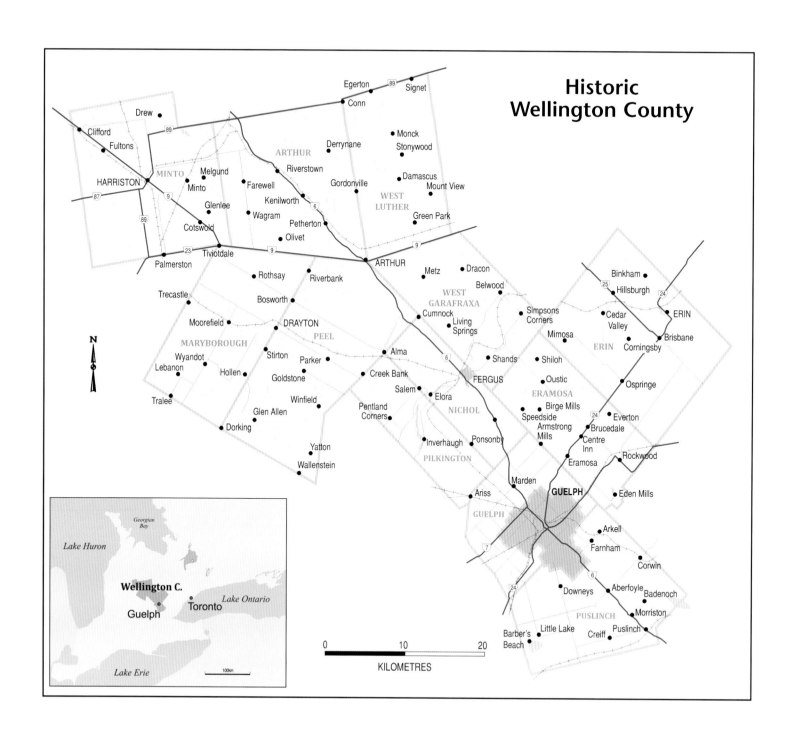

Historic
Wellington County

Introduction

WELLINGTON COUNTY EXTENDS almost a hundred kilometres from south of Highway 401 near the Region of Hamilton-Wentworth to Clifford on the edge of Grey County in the north. The most westerly extension of its irregular boundary abuts Huron County. In the east it reaches the Town of Caledon. In 2001, Wellington's population, including Guelph, was 187,131 and its land area was 2656.65 square kilometres. Its towns, countryside, history, economy, problems and prospects for the future are all explored in this book

Wellington County was settled between the 1820s and the 1880s. Its history is filled with tales of hardship and change, successful pioneers and failed settlement schemes, prosperous communities and ghost towns. Early surveys and government incentives encouraged pioneers to clear the land quickly. They came from the south and east, following surveyors and road builders north and west.

Wellington County provided myriad opportunities and challenges to the pioneers. Underlain by the Guelph and Lockport formations of limestone and dolomite, it offered abundant supplies of excellent material with which to construct sturdy stone buildings. Much of the bedrock has been covered by more recent glacial deposits of gently rolling till, tumbled moraines, cigar-shaped drumlins, level outwash plains and sinuous eskers that endow the land with endless variety. Wellington County has also been blessed by numerous lakes, streams, swamps and forests. Its diverse physical foundation provides an excellent basis for the complex and prosperous county that we enjoy today.

We begin with Wellington's physical legacy because water and stone were essential to the county's development. Chapter One describes the streams that provided the first routes into the dense forests blanketing the land and supplied water power to run the mills. Almost every successful community in the county began at a dam site where water plunged into a rocky gorge. Roads constructed between these rapidly growing mill towns were soon followed by the railways. Today lakes created by damming the streams provide some of our most attractive recreational areas and ensure that waterways continue to flow during droughts. The Elora Gorge and the Rockwood Conservation Area display some of the most spectacular limestone formations in the province. Without water and stone, Wellington County could not have attained its contemporary character.

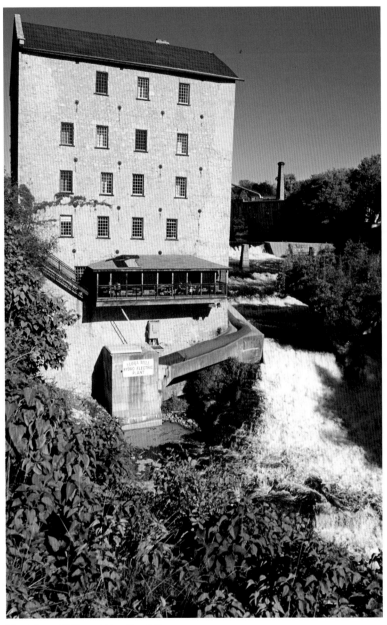

The Elora Mill and Tooth of Time.

Chapter Two discusses building with limestone, and then describes some of the magnificent structures constructed in the county by skilled Scottish masons. Guelph and Fergus are particularly rich in limestone churches, business blocks and homes, but many other smaller communities possess excellent examples of stone construction. Across the countryside, a wide variety of stone farmhouses and even a few well-preserved stone barns may be discovered.

Agriculture was initially the economic foundation of Wellington County and continues to be extremely important. Chapter Three discusses the prospects and problems confronting farmers in Wellington County through a number of case studies. We visit a century farm that has evolved from subsistence agriculture to cash cropping. Then we explore a specialized elk farm, a successful hobby farm and a local winery. Each illustrates the human dimension of continuing to make a living from agriculture in the twenty-first century. The vast diversity of land use and agricultural practices across the county is also explored.

The fascinating history and architecture of Guelph are described in Chapter Four. Established as a planned town by John Galt in 1827, it grew rapidly because of his efforts to attract skilled artisans and businessmen. They quickly built the economy and erected many outstanding limestone buildings. Guelph soon became the county seat and the largest settlement in Wellington County. Today it retains much of its early charm, but faces numerous problems presented by rapid population growth and economic development. Its quiet tree-lined streets, tranquil parks, outstanding university, limestone architecture, proximity to the Greater Toronto Area and numerous employment opportunities continue to attract new residents.

Elora and Fergus were founded within two years of each other, but have evolved into very different communities. Chapter Five compares and contrasts their development. Today Fergus is a rapidly growing residential and industrial community with a rich legacy of limestone architecture. The annual Scottish festival is its major attraction for tourists. Hard work by entrepreneurs and local businessmen transformed Elora from a sleepy mill town into a major tourist destination. They renovated the massive mill, promoted the "Mill Street Economic Revival" and established the Elora Festival. Today Elora attracts sightseers and music lovers from far and near.

Chapter Six delves into the origins and development of some of the smaller communities in the county. In addition to the prosperous mill towns, many others were established at crossroads to serve the local farmers. Some have disappeared entirely and have become ghost towns, remembered only as dots on ancient maps. Others have attracted small businesses or retirees and have become prosperous once again. All have fascinating histories. The largest retain picturesque buildings that reflect their earlier growth and prosperity.

Wellington County has an extremely rich and varied community of artists and artisans, the focus of Chapter Seven. Almost everyone is familiar with Ken Danby, but fewer may know the outstanding work of Paul Morin. Jessica Steinhaüser, Hok Wee and Tiffany Horrocks are eminent potters and sculptors living in Guelph. Many local studio tours and exhibits display the creations of our artists and artisans year-round. The Macdonald Stewart Art Centre in Guelph has become recognized internationally for its collections of Canadian art and for its numerous publications.

Chapter Eight deals with Wellington's prospects. Although there are numerous problems such as water shortages, traffic

Fergus Scottish Festival and Highland Games.

congestion, air pollution and wildly fluctuating prices for agricultural products, Wellington County has vast potential to solve these problems and to grow in a sustainable manner. For this to occur, even more concerned citizens must become involved in local politics and elect councillors with foresight and intelligence. The future will be bright if Wellington's citizens pay attention to the important issues and get involved in its planning and politics.

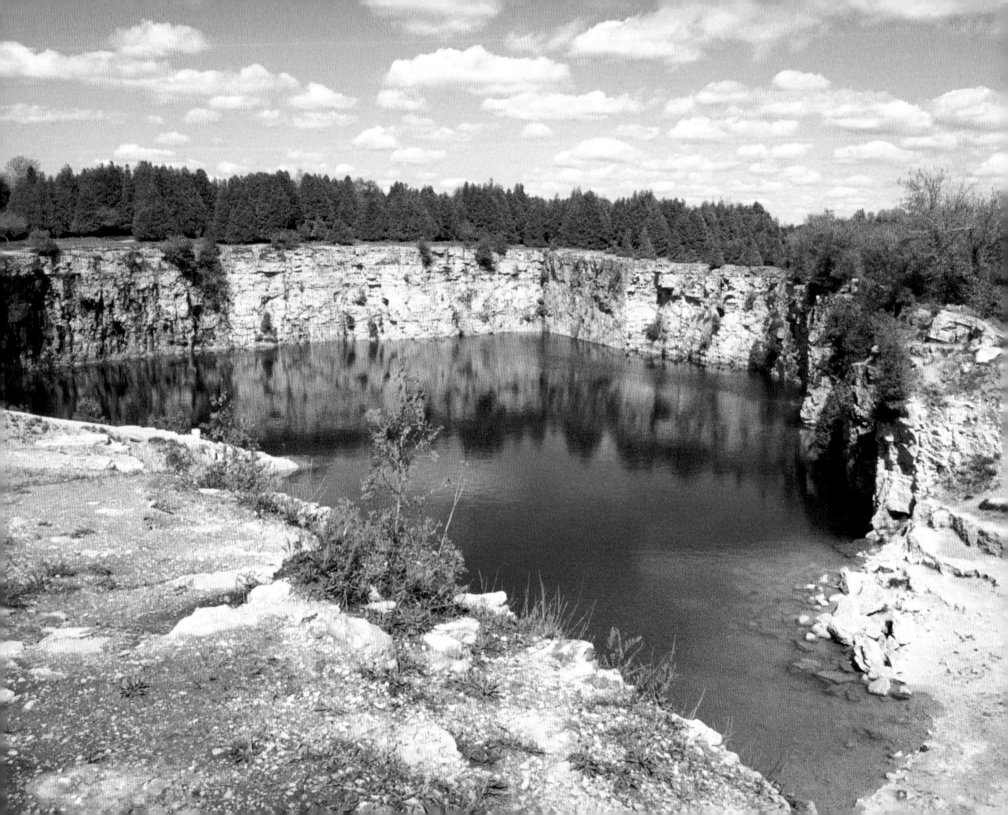

Water

WATER IS A CRUCIAL COMPONENT of contemporary civilization and has been of paramount importance since the beginning of time. Water has always been essential to the residents of Wellington County. When the pioneers arrived, rivers became their highways into the wilderness. Water power from the first dams encouraged them to establish settlements nearby. Today rivers supply drinking water, provide recreational areas and carry sewage effluent from our settlements.

In the Beginning

The land that became Wellington County began to evolve over three billion years ago when the earth was a cooling molten mass. Volcanoes erupted, tectonic plates shifted and the climate changed continually. By the late Paleozoic Era, some 250 million years ago, North America was part of Gondwanaland, a slowly drifting predecessor of today's continents. Sweeping, shallow tropical seas teeming with fish and reptiles covered much of the planet. Lush rain forests abounding in exotic plants and animals lined the shores. Waves washed gently across the water, slowly depositing silt, clay and tiny particles of calcium carbonate, which became layers at the bottom of the sea.

As eons passed, these materials compacted and solidified, slowly producing strata sprinkled with fossils of fish, coral and reptiles. The sediments eventually became limestone, sandstone and shale, which blanketed the Precambrian basement below. Much later, folding and faulting tilted the strata, and continental drift began to change the face of the land. Slowly the water receded, but before Wellington's terrain developed completely, new continents were formed, climatic changes took place, and glaciers repeatedly sculpted the surface of the land.

During the recession of the Wisconsin glaciers some 12,000 years ago, much of Ontario was covered by sheets of ice over a kilometre ($2/3$ mi.) thick. Continental glaciers

This former limestone quarry, long a popular swimming hole, is now a major attraction at the Elora Quarry Conservation Area.

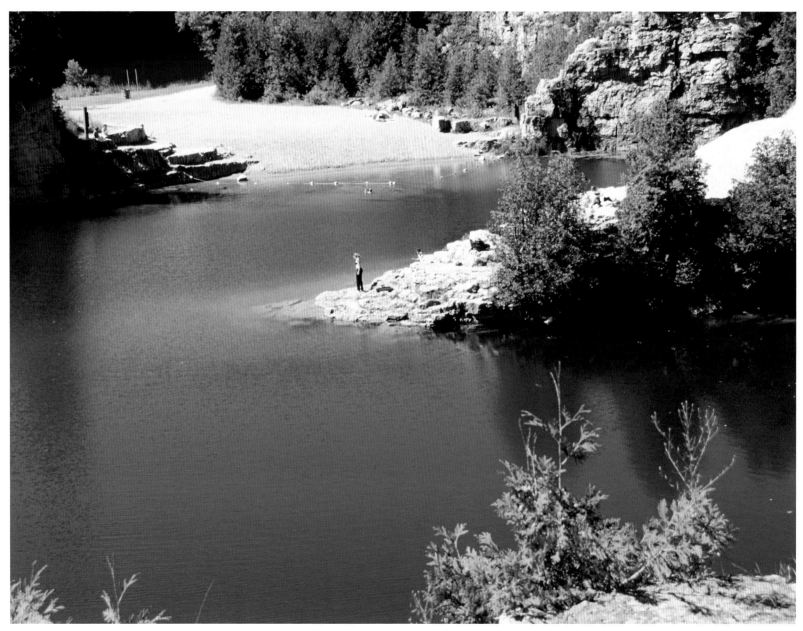

Wellington's contemporary landscape reflects recent human impacts but its geological legacy persists.

expanded in all directions from the Great Lakes and Hudson Bay. Those affecting southern Ontario advanced slowly north and east from Lakes Huron, Ontario and Erie. When temperatures fluctuate, glacial ice advances or retreats, oozing across the bedrock in its path. Vast, milky, meltwater streams carry rocks, silt and sand that are deposited on the sedimentary strata below. The hills, valleys and soils greeting this area's earliest visitors were shaped first by events in the Paleozoic Era, and much later by those in the Wisconsin glacial period. Wellington's contemporary landscape reflects recent human impacts but its geological legacy persists.

The Gorges of the Grand

Elora and Fergus both lie on the Grand River where the Grand and its glacial predecessors slowly dissolved a deep abyss into the soluble limestone of the Guelph Formation of the Lockport Dolomite, cutting through the cap rock and tilted strata below. The gorge of the Grand River at Elora is the county's most impressive sight and has attracted tourists since 1817. Thousands of visitors have stood at Lover's Leap, which got its name from the story of a native warrior and his beloved. Upon hearing the news that the young man had been slain in battle, his sweetheart flung herself off the point onto the craggy rocks below. Today tourists peer from this lookout above the confluence of the Grand River and Irvine Creek at the rushing water and caves in the gorge. Twenty-eight metres (92 ft.) below, two streams combine, freshets from each mingling and foaming as they converge in their mad dash beneath cedar-clad cliffs.

The descent to the river on stairs nestled between algae-covered boulders has been a popular pastime for decades. In

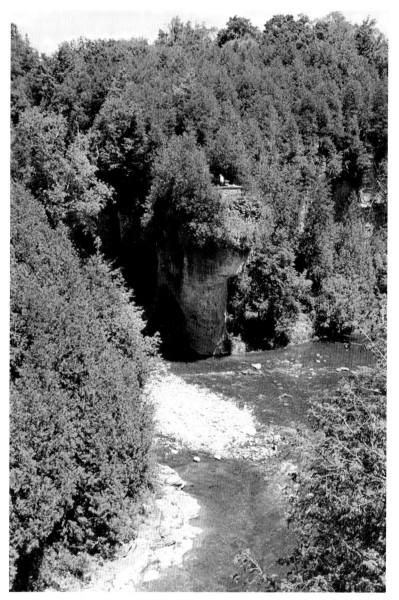

Thousands of visitors have stood above the Grand River at Lover's Leap, which got its name from the story of a native warrior and his bereaved lover.

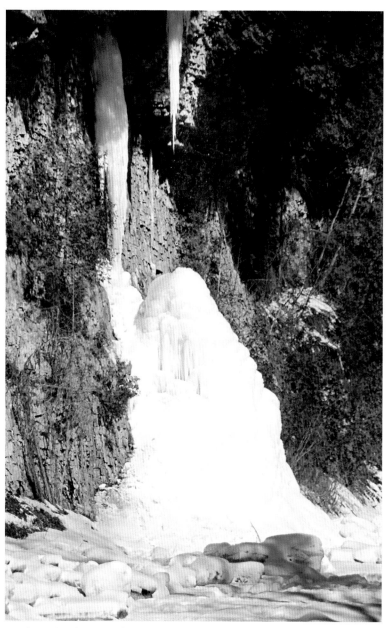

In winter icy fingers of runoff reach for the snow and ice below.

the cool of the gorge, water drips from the overhangs and trickles slowly to the river. In the winter these flows become long, sleek fingers of ice, clutching at the snow like giant frosty hands. Water swirls beneath the ice, making delicate patterns, eddies and whorls where it struggles through the few open stretches. Delicate patterns of crystallized precipitation flow across the grey limestone chasm, imparting mystery and icy charm to this world of white and green. From time immemorial, the Elora Gorge has attracted visitors and provided water power for mills in Elora. Today it is a favourite destination for hikers, rafters, kayakers, inner tubers and canoeists.

Fergus, a few kilometres upstream, was also founded because of a dam site on the Grand. The Fergus chasm is not quite as large or spectacular as the gorge at Elora, but it possesses its own unique beauty. Here the river cascades into a whirlpool called Mirror Basin, which has claimed the lives of several careless swimmers. At its edge, the rugged limestone is lined by a walkway and park bordering the swirl of frothing water. Templin Gardens, built in the late 1820s, is a flowery oasis of variegated colours beside the river. Its stairs provide access to the water, and a walkway along the cliff joins two nearby bridges. In the wall of the abyss several caves may be found. One, called the CPR cavern, was a favourite location for the manufacture of bootleg liquor. It was named for a Canadian Pacific Railway lantern found there by local speleologists.

In 2004 the successor to the original dam was removed after high water breached part of the structure. Now the river and falls look almost as they did before the dams were constructed. Water again flows freely, displaying the power that attracted settlers and their mills to the site.

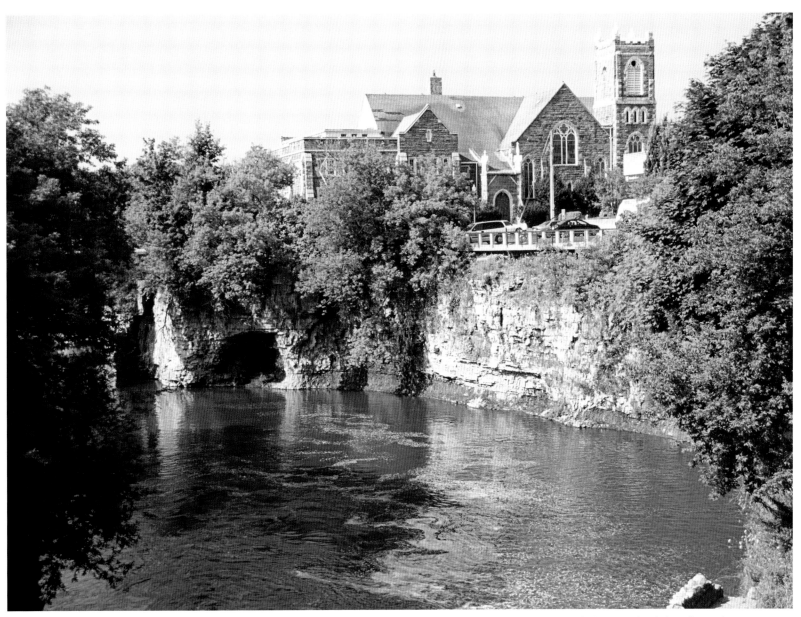

The Grand River Gorge has always attracted visitors and once provided water power for mills in Fergus and Elora. Today it is a favourite destination for hikers, rafters, kayakers, inner tubers and canoeists.

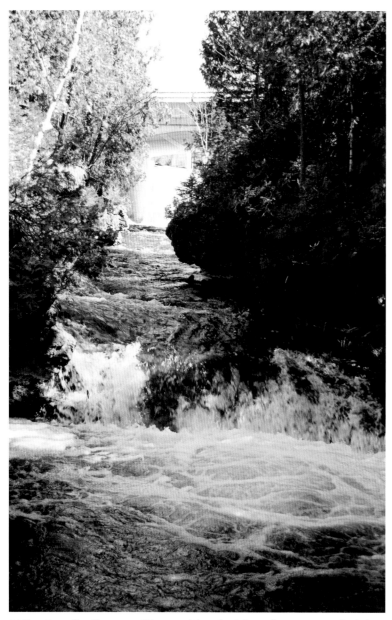

The Eramosa River Caverns and Potholes

Waterfalls and dams on the Eramosa River powered early mills at Rockwood and Everton, several of which remain. The numerous spectacular potholes in and beside these rivers were created some 12,000 years ago by torrential meltwater from the edges of the receding glaciers. At Everton, the Eramosa River and its glacial predecessor eroded the limestone to form a steep falls and rugged gorge enclosing the foaming torrent. Water from melting glacial ice swirled in turbulent eddies, causing harder Precambrian "grinders" to scour holes in and around what is now the stream bed. These almost perfectly circular pits are found behind the derelict Hortop Mill beside the falls. Several

At Everton, the Eramosa River and its glacial predecessor eroded the limestone to form a steep falls and rugged gorge.

Several circular potholes remain along the banks of the Eramosa.

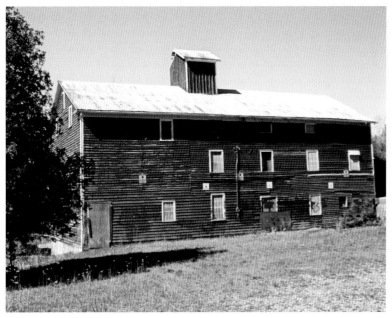
In Everton, Hortop's red wooden mill still stands, a reminder of the era of water power and dams.

circular potholes remain along the banks and under the water tumbling over the falls and gorge. The dam and millpond across the road are evidence of the river's previous importance. Hortop's red wooden mill still stands, a reminder of the era of water power and dams.

From its origins as a mill town, Everton has evolved into a popular commuter dormitory and quiet rural residential retreat. What was once a hive of commercial and industrial activity now attracts residents to enjoy its beauty, tranquility and proximity to jobs in Guelph and Erin. Modern houses nestle along its streets. At various times the once-elegant hotel at the edge of the hamlet on County Road 124 has been reincarnated both as a restaurant and a residence.

Valleys and Misfit Streams

When glaciers advanced and retreated, their meltwater cascading away from the ice created enormous valleys called spillways. Today rivers such as the Grand, Eramosa, Conestogo and Speed are called misfit streams because they flow along spillways eroded by these massive torrents from the glaciers. Their valleys are much too large to have been created by the contemporary streams that flow there now. Postglacial rivers could never have created such large depressions in only 12,000 years. Excellent examples of glacial valleys with misfit streams are found where the Speed River crosses Victoria Road in Guelph and along the Eramosa River at Eden Mills.

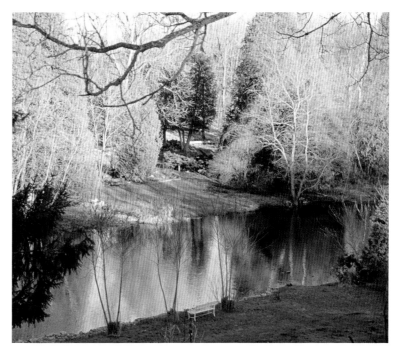
Picturesque rivers and streams abound in Wellington County.

Eden Mills lies in the broad, wooded glacial drainage channel that once carried meltwater from the ice to the Lake Ontario basin. This spectacular depression became the site of the village, with seasonal cottages and permanent homes nestled in a miniature wilderness. Eden Mills was once primarily a mill town, service centre and summer resort, but has become a commuter dormitory for Guelph and Toronto. Its pond, river, hills, cedar woods, quiet environment and accessibility have made it a favourite residential retreat in the heart of Wellington County. Its former grist mill has been converted into a residence

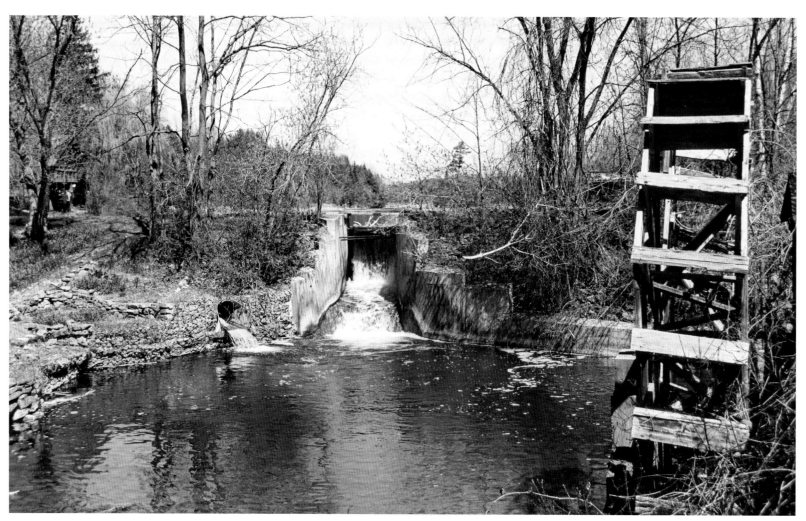

Eden Mills was once primarily a mill town, service centre and summer resort.

and architect's studio, while the dam and falls remain. The hamlet has become famous for its annual Eden Mills Writers' Festival. Founded in 1989, the festival has grown steadily and attracts international authors to present outdoor readings each September. Additional entertainment for the hundreds who attend is provided by dancing and Scottish pipe bands.

Caves and Giant Potholes at Rockwood

The history of the Rockwood area is considerably more complex than that of communities on the Grand. In this area glacial ice formed a dam that blocked meltwater, creating a local lake many metres deep. During a long period at the end of the Wisconsin glaciation, torrents of milky, silt-laden

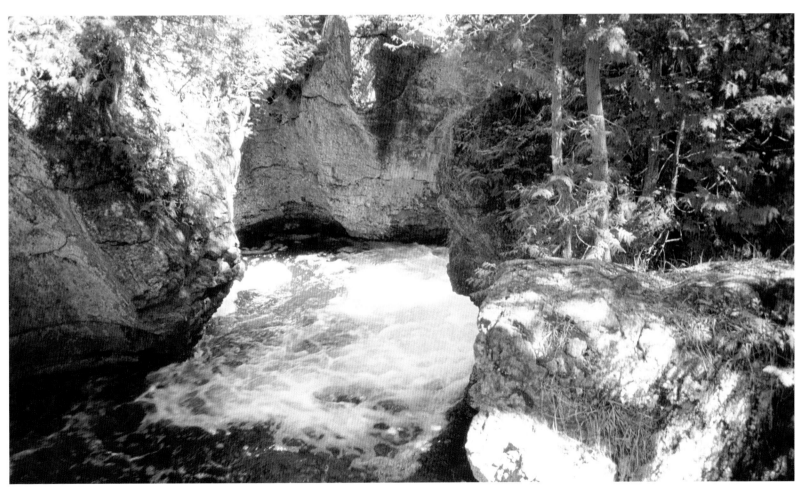

In the Rockwood Conservation Area, where torrents of milky, silt-laden meltwater ebbed, flowed and eddied, swirling hard Precambrian grinders to create over 300 giant potholes.

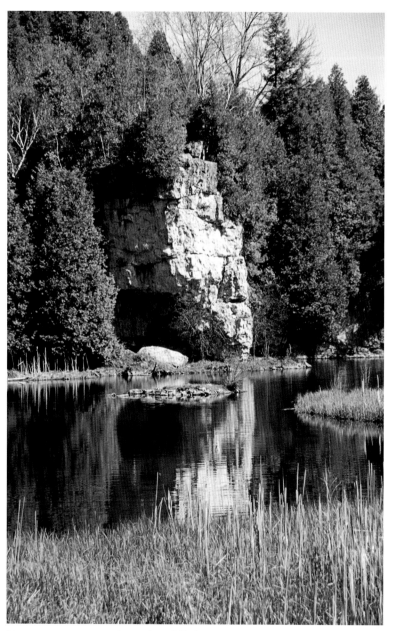

Limestone caverns along the cliffs beside the river and millpond.

meltwater ebbed, flowed and eddied, swirling hard Precambrian grinders to create over 300 giant potholes. The largest is the Devil's Well, bored deep into the rock on the top of a ridge over 20 metres (66 ft.) above the present river. It can be reached from an abandoned quarry only by scrambling through heavy underbrush and up a dangerous, rocky cliff. During glacial times this pothole was eroded at the bottom of an enormous stream that scoured a rugged gully into the bedrock. Water then rushed from the Devil's Well to another valley 15 metres (49 ft.) below. Unfortunately, because the Devil's Well is almost inaccessible, it has been omitted from Rockwood Conservation Authority maps.

Numerous limestone caverns along the cliffs beside the river and millpond are equally fascinating. They were formed when dilute acids in water covering the strata slowly permeated joints and bedding planes, dissolving the limestone and leaving tunnels and grottos. Much later, after the lake covering the caverns receded, rain percolated down cracks into the cavities. The dripping water eventually created stalactites reaching down from the ceiling, stalagmites stretching from the floor below, and flowstone on the cavern walls. Their development is similar to but infinitely slower than that of icicles during the winter, and they are composed of calcium carbonate rather than frozen water.

The most accessible cavern at Rockwood penetrates a cliff beside Valley Road that extends from the old Harris woollen mill to Highway 7. Once called the Devil's Kitchen, its wide, 9-metre-high (29$^{1}/_2$ ft.) entrance leads to narrow tunnels just over 40 metres (130 ft.) long. Inside the largest tunnel there is a room almost as high as a person, once decorated with stalactites and stalagmites. Unfortunately, most were destroyed by "explorers" who collected them as souvenirs. Several other

narrow passages descend into the depths, but are clogged with mud that blocks further penetration. Nevertheless, the Devil's Kitchen, more recently called Rockwood Number One Cave, has been a fascinating introduction to speleology for hundreds of interested visitors including the author.

Elsewhere in the area, smaller caverns exist below the waterfall, along the bases of cliffs and in the woods, but none are as large, accessible or spectacular as Number One. Nowhere else in southern Ontario can one discover such an array of limestone cliffs, caverns and potholes in such a tiny area so close to Toronto and Guelph.

Rockwood Conservation Area

In 1958 the Grand River Conservation Authority purchased 80 hectares (200 acres) of the Eramosa valley in Rockwood from Edgar Harris who owned the mill. It now manages the land as a camping and recreational area featuring the wonderful geology of river, pond and cliffs. Long before it was purchased by the Authority, this unique limestone enclave attracted tourists from afar. It was a favourite spot for picnics, wedding photographs and hiking. After the Harris Woollen Mill closed in the late 1920s, the family created Hi-Pot-Lo-Park, a splendid sanctuary that included the millpond, trails to the high cliffs above the pond, the Devil's Well, hundreds of smaller potholes and numerous caves. Near the ruins of the mill on Valley Road, the Harris family constructed an ornate entrance with stone fireplaces at either end. For a small fee, visitors could follow a series of paths through the rugged limestone topography and woodlands to the lake and potholes.

Washrooms, picnic tables and spring water were made available to visitors who could climb 25 metres (82 ft.) above

Rockwood Conservation Area.

23

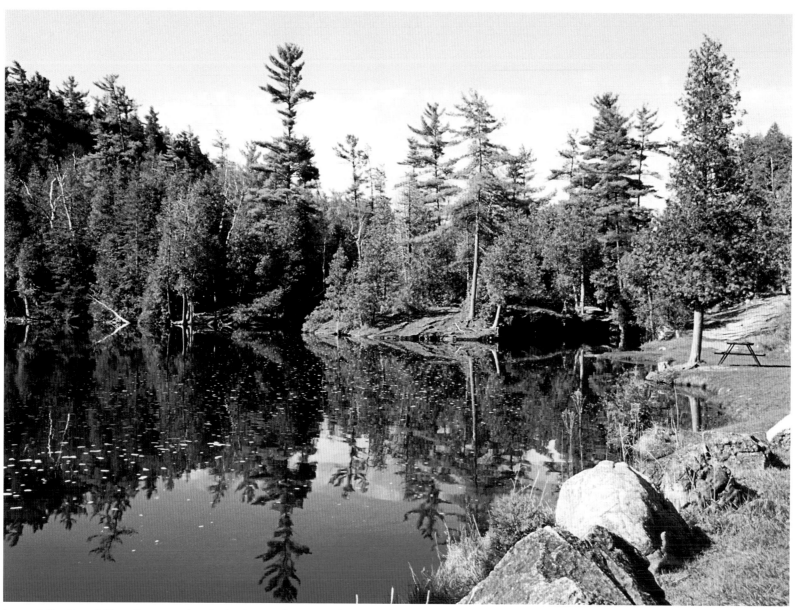

In 1958 the Grand River Conservation Authority purchased 80 hectares (200 acres) of the Eramosa valley in Rockwood from Edgar Harris who owned the Harris Woollen Mill.

the lake and observe Pot Hole Island from Lookout Point. Three pavilions south of the river accommodated church picnics and social gatherings. The park became a very popular destination for families and groups who could enjoy a unique natural area within an easy drive of Kitchener, Guelph or Toronto. Before the land was purchased by the Conservation Authority, many high school students explored their first limestone cavern there.

The well-preserved ruins of the 1867 woollen mill recall the era when Rockwood was a thriving industrial centre. In addition to the mill and its offices, the valley contained the elaborate Harris homestead and a number of houses for his workers. There are also remnants of several limestone quarries and lime kilns, of which the first were established in 1898 and the last closed in 1965, when the Rockwood Lime Company ceased operations. Just beyond the park boundaries, the grist mill built by Henry Strange around 1843 has been restored as a handsome residence. For many years the valley's businesses were the economic nucleus of Rockwood, producing lime, building stone, woollens and flour.

Today the conservation area with its beach, hiking trails and camping protects this unique glacial landscape. In the summer, fishing, canoeing and swimming are popular. During the winter, its trails provide spectacular views of the lake and excellent cross-country skiing. A wide variety of plants and animals enrich the experience of the 50,000 visitors who come each year. Because of the fragility of this exceptional area, campsites near the lake are being naturalized to decrease their impact on the landscape and ecology. It is a unique and fascinating natural environment close to major centres of population.

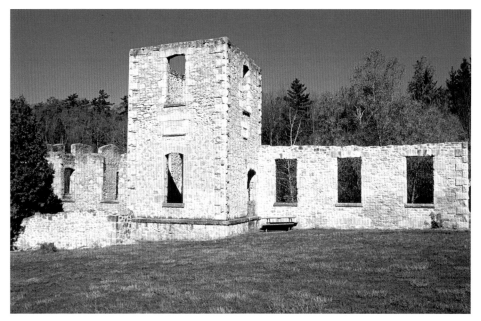

The Harris Woollen Mill, built in 1867.

A Legacy of Glaciers and Climate

Most of the bedrock in Wellington County is buried under glacial deposits called till. As the ice melted, water flowed under the glaciers, depositing sediments in the tunnels that formed. When the glaciers melted, the former tunnels emerged as long, sinuous hills of sand and gravel called eskers that snake across the landscape. Beyond the margins of the ice, the spreading streams dropped more sediments that became outwash plains and deltas of silt, clay, sand and gravel. Many such deposits are now valuable sources of building material. In urban areas most have been exhausted, but the remains of an esker and a glacial delta remain near the Hanlon Parkway in Guelph. The county is dotted with

wayside sand and gravel pits supplying aggregates for local construction.

Much of Puslinch Township has been excavated for its scarce and valuable aggregate deposits. It is also a major repository of aquifers containing enormous volumes of groundwater. Large areas have been scarred by extensive water-filled excavations surrounded by heavy cranes extracting sand and gravel from their depths. Abandoned pits remain as small lakes, making Puslinch resemble a pockmarked meadow of grass and water from the air.

Gravel pits are great economic assets for their owners, but they generate noise, dust, heavy truck traffic and air pollution. Many residents of Puslinch oppose additional aggregate extraction and would like to see the demise of active pits.

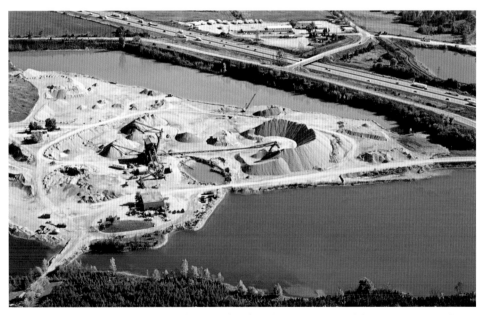

Much of Puslinch Township has been excavated for its scarce and valuable aggregate deposits.

Their dreams of a quiet life in a bucolic country retreat have been shattered by the cacophony and exhaust of dredges and trucks. As in the case of bottled water, considerable conflict exists between entrepreneurs wanting to exploit geological resources and citizens wishing to preserve their chosen lifestyle and the natural environment. Meanwhile, human impacts continue to alter the township as the prices and demands for aggregates and water increase.

Hills and Dales

For thousands of years massive grey-blue lobes of ice oscillated slowly back and forth, carving, crushing and carrying the bedrock. At the perimeters of the glaciers some of this material was deposited and then bulldozed into rocky, tumbled hills called moraines. Large areas of Puslinch and Erin Townships were avoided by early settlers because of their steep, rugged moraines and surface rocks called erratics. These areas have become prime areas for rural residential estates and reforestation.

Material deposited under the ice became till (deposits of mixed sand, silt and gravel), which is relatively level and provides an excellent foundation for soil formation. Some till was overrun and streamlined by the moving ice, becoming long, narrow, cigar-shaped hills called drumlins. Many are found in Eramosa and Erin Townships, where roads run like roller coasters over the steep sides of these picturesque knolls. In Guelph the Church of Our Lady surmounts one of the largest drumlins in the area, overlooking gravel terraces along the misfit Speed River below.

Wellington's rolling hills, undulating plains, wide stream valleys, deposits of sand and gravel, swamps and preglacial

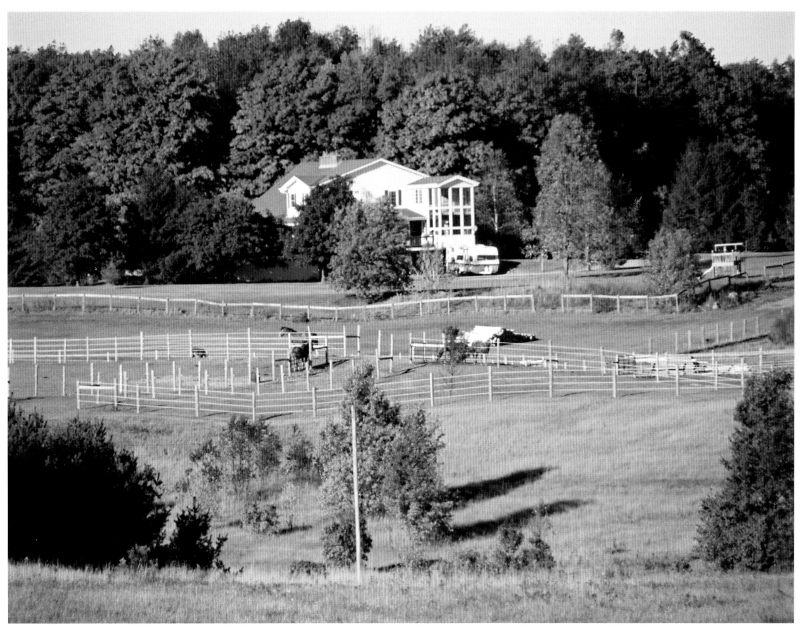

The rugged moraines of Puslinch and Erin Township have attracted hobby farmers and commuters.

Roads run like roller coasters over the steep sides of drumlins in Erin Township.

gorges provided many opportunities and challenges for the settlers. Between the end of the Wisconsin period and the arrival of the first inhabitants, a variety of soils formed where organic material collected on glacial deposits. The county's most fertile areas evolved where till or outwash plains were well watered and reasonably level. They attracted some of the earliest migrants, who created prosperous farms in townships such as Maryborough, Pilkington, Guelph and Peel.

Wet, low-lying regions and swamps such as the Luther Marsh were generally bypassed and settled late. They were difficult to traverse and blanketed by a mixture of water, heavy, mucky soils and dense, tangled vegetation. Similarly, the steepest drumlins and moraines were initially avoided, and often left for years in forest cover. They ultimately attracted nonfarm residents, hobby farmers and commuters who created some of the county's most prosperous and attractive residential enclaves. Wellington's popular recreational areas for fishing, camping, hiking and boating were developed around its rivers, lakes, valleys and hills. Now they offer respite and rural solace to nearby residents, tourists, campers and hikers.

Some Natural Lakes

Puslinch Lake in the extreme southwest of the county was once a popular summer resort. It is now plagued by silting and extensive algae growth. With an area of almost 160 hectares (400 acres), it is North America's largest kettle lake, formed when glacial ice buried in till melted, leaving a depression that filled with water. Unfortunately, much of it is now only a couple of metres deep and unattractive for swimming. Its restoration for swimming and fishing will be difficult because of nutrient-rich runoff from farm fields and

seeping septic tanks. What was once a pristine country retreat now resembles an urban lake in the midst of burgeoning residential development.

Pike Lake just west of Mount Forest has suffered much the same fate. Both Pike and Puslinch Lakes are ringed by crowded older cottages competing for space with luxurious summer homes and permanent mansions in exclusive subdivisions. Much of the recent residential development near Pike Lake has been attracted by a splendid new golf course.

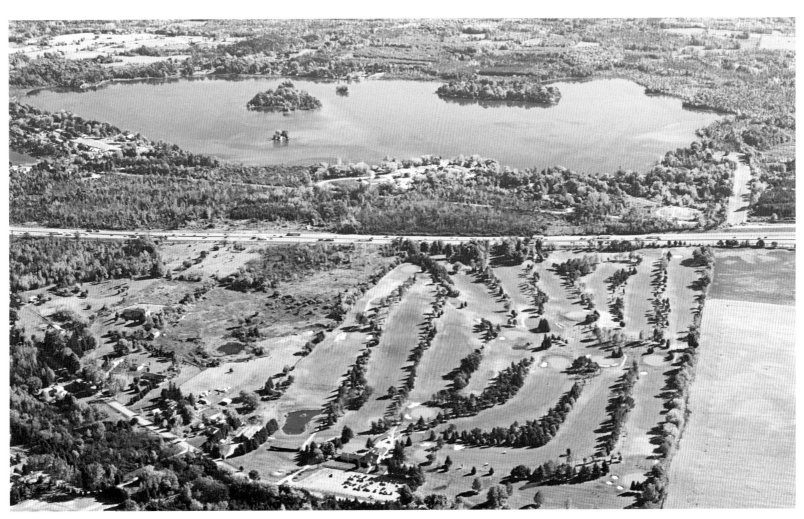

Puslinch Lake and adjacent golf course.

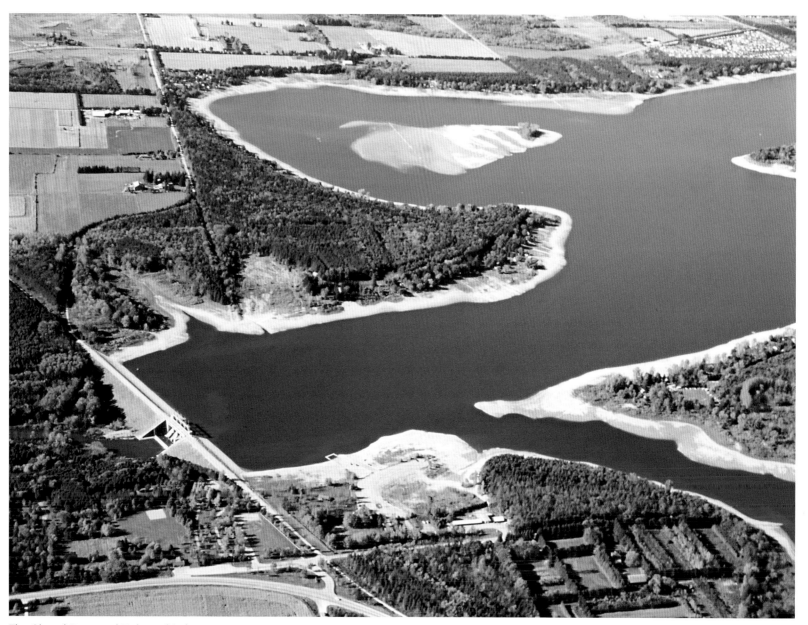

The Shand Dam and Belwood Lake.

Grand River Conservation Authority Lakes

During pioneer days flooding was not a problem along Ontario rivers. Sadly, years of clearing land for farming and settlements completely changed the picture. Forests were cut, land was plowed and spring runoff increased. Instead of being absorbed slowly into the soil, spring rain and melting snow discharged increasing volumes of water into the streams.

Floods began to occur almost every spring, and during dry summers, waterways became low and sluggish. No longer did stored moisture seep slowly into the water table and sustain adequate flows. In some streams, volumes have become insufficient to maintain satisfactory water quality, causing fish and wildlife to suffer and necessitating heavy chlorination to make river water safe to drink. In several waterways, effluents from sewage treatment facilities constitute a large and increasing proportion of their summer flows. Rapid urbanization and factory farming continue to exacerbate what has become a serious situation.

Unfortunately, flood plains provide optimum conditions for farming and for urban development. Level, fertile, easily cultivated land is ideal for both. By the early 1900s a series of major floods caused severe hardship, damage and expense in the Grand River valley. In 1929 the largest and most damaging flood in living memory inundated the business areas of Brantford, Paris and Galt. As a result, the Shand Dam was built where the Grand River cuts through the Orangeville Moraine just north of Fergus.

Belwood Lake

The Shand Dam was built in 1942 and created Belwood Lake, a 12-kilometre-long reservoir ($7^1/_2$ mi.) with a storage capacity of more than 63.6 megalitres (14 million gal.). Water from the dam is used to generate hydroelectricity as well as to regulate the level of the river. About 350 seasonal private cottages surround the lake on land owned by the Grand River Conservation Authority. Nearby, a golf course and several retirement communities have taken advantage of proximity to the lake and Fergus.

Conestogo Lake

The Conestogo reservoir was created by a dam on the Grand near Drayton in 1957. The lake covers over 2,300 hectares (5,680 acres) and is used extensively for power boating, sailing, jet skiing, water-skiing and canoeing. Its huge concrete flood-control dam and reservoir are surrounded by large tracts of forest, creating the illusion of a remote wilderness.

Part of Conestogo Lake's shore is managed by the Grand River Conservation Authority, which offers campsites with hydro and water hookups. A successful pheasant release program provides 1,500 birds for hunters each fall. Along the eastern shore, private dwellings range from modest clapboard structures to spacious modern year-round retirement homes. Conversions of former cottages to permanent dwellings continue to increase as people age and seek a rural retreat.

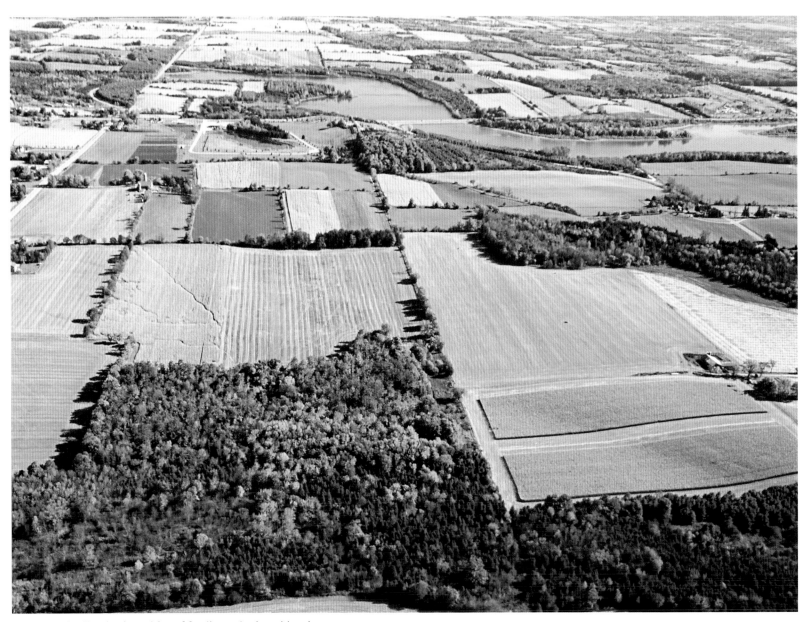

Guelph Lake lies in the midst of fertile agricultural land.

Guelph Lake

A dam built in 1976 on the Speed River north of Guelph near Road 124 created Guelph Lake. This 7-kilometre-long (4⅓ mi.) lake and its park have become popular for day use, camping, fishing, sailing, wind surfing and canoeing. Motorized craft are not allowed. Numerous group facilities and individual campsites are provided among its trees and fields. Its proximity to the city, large size and excellent amenities have made it a preferred location for special events such as Boy Scout jamborees, various competitions, triathlons, group camping and tournaments.

Every spring, dragon boat races attract hundreds of competitors who paddle their long, elaborately ornamented craft along Guelph Lake. For several days, the lake resounds to the calls of boaters and the rhythmic pull of their paddles. The shore is thronged by spectators and competitors in brightly decorated uniforms, waiting to take their turns on the water. A colourful tent city provides food and souvenirs to the thousands who attend. Volunteers direct parking and ensure that the races are conducted properly.

The Hillside Festival occupies the Guelph Lake island every July. This annual event hosts well-known international artists who share the stages with local musicians. The Barenaked Ladies are among many groups who have performed at the festival and subsequently become famous. Musicians now line up to be included in the program, which is sold out to a capacity crowd of 5,000 several months before the event. Top bands perform on the main stage with its living roof, and others play on smaller stages scattered across the island. The audience, sitting on benches under tents, or on

Every spring, dragon boat races attract hundreds of competitors.

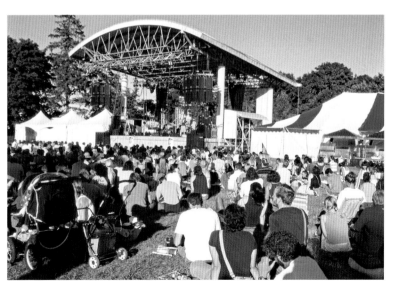

The Hillside Festival occupies the Guelph Lake island every July.

portable chairs or blankets on the grass, enjoy performances that appeal to people of all ages.

During the day workshops and concerts are presented in tents and on the stages. Hillside's organizers are committed to preseving the environment: Volunteers wash all plates and utensils, and beer is served only in reusable mugs sold for the purpose. Swimmers frolic in the water, participants camp nearby, and small, colourful sailboats grace the lake. No commercial sponsorship is allowed and the audience is encouraged to travel from Guelph on special buses rather than in their cars. Hillside Festival has become renowned for its ecologically friendly approach, outstanding entertainment and lack of rowdiness or drunken patrons. The limited capacity of the island ensures that Hillside Festival will remain small and superb.

When the Guelph Lake dam was constructed, the river flooded roads, farms and a small park. Although this generated some controversy, the stumps and ruins under the water now provide excellent habitat for pike, bass, carp, perch and black crappie. During the winter, ice fishing from huts continues to grow in popularity. Recent improvements and reforestation have improved cross-country skiing and hiking trails in this modern, year-round facility.

The Grand River Conservation Authority has created a large, modern year-round park at Guelph Lake.

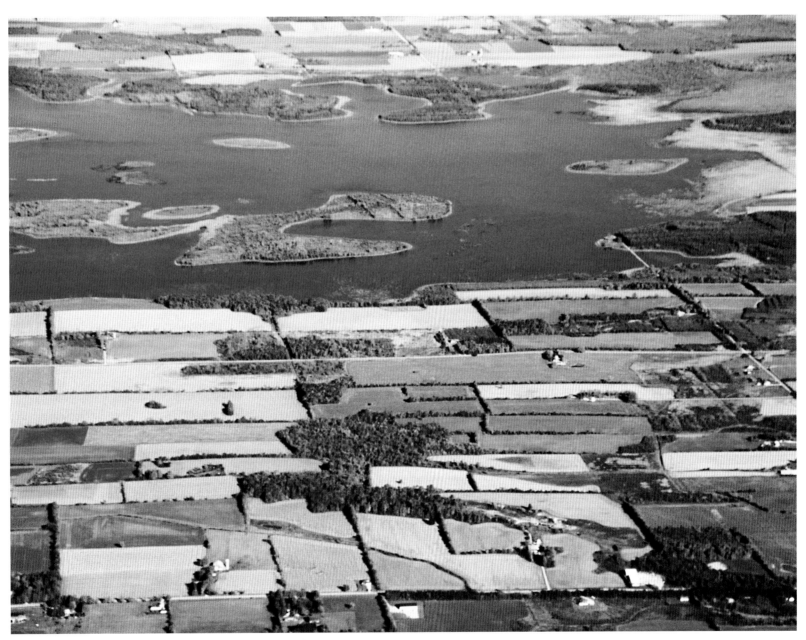

Luther Lake, an ecological treasure in Wellington North.

The Luther Marsh Wildlife Management Area

Some of Luther Marsh is in West Luther Township, a remote and difficult landscape in the extreme northeast of Wellington. It was surveyed originally by Lewis Burwell, whose work was considered inaccurate and had to be redone. Burwell skirted around it and the adjoining township, labelling the interior "all swamp." As a devout Roman Catholic, he named the townships after Martin Luther and Melancthon, two leaders of the Protestant reformation and "the meanest men he knew." He believed that their names were appropriate for the meanest land that he had ever surveyed.

In 1881 Luther was split into east and west sections, with East Luther joining Dufferin County and West Luther remaining in Wellington. Today West Luther Township supports some prosperous farms but is best known as the location of a portion of the Luther Marsh Wildlife Management area. When the township was cleared and drained, more and more runoff occurred, causing floods on the Grand River. Concurrently, the size of the swamp diminished considerably, disrupting its ecological system. In 1954 a dam was built across a tributary of the Grand at Black Creek where it drained Luther Marsh. This reservoir is used to catch water when there is a surplus, and to release it slowly in times of drought. During dry summers, flow augmentation helps provide downstream communities with enough water to maintain acceptable quality for drinking and for wildlife habitats.

The lake and swamp have created a biological treasure that is one of southern Ontario's most significant wetlands and wildlife habitat areas. The Grand River Conservation Authority and the Ontario Ministry of Natural Resources jointly administer the reserve, which contains over 5,200 hectares (12,850 acres) of incredible ecological diversity. Its 1,400-hectare (3,460-acre) open marsh reservoir is surrounded by crop land, lowland swamps, shrubby bogs, natural forest and plantations that provide excellent habitats for a wide range of plants and animals.

Whether they come to nest or gather to migrate, over 237 different species of waterfowl visit the marsh. The swamp is home to 35 varieties of mammals, 10 species of amphibians, 12 types of fish and 11 kinds of reptiles. The mink frog, spotted turtle and ribbon snake are among the unusual inhabitants of the sanctuary. Wylde Lake is a superb example of a boreal bog, supporting uncommon plants such as the royal fern, tawny-cotton, round-leafed sundew and small cranberry.

Although access is from East Luther Township, Wellington residents can easily enjoy the facilities and attractions of Luther Marsh. In addition to wildlife, these include snowmobiling, snowshoeing, birding, hunting, hiking, mountain biking, skiing, nature observation, canoeing, picnicking and photography. Educational tours and research facilities are also available. Trails, canoe routes, picnic areas, boat launches, displays and observation towers have been provided for visitors. The Luther Marsh is an invaluable asset that preserves local ecology and provides an intimate glimpse of natural habitats for exotic birds, plants and animals.

Water was responsible for much of the early exploration of Wellington County and for the establishment of its most successful communities. As we confront climate change with its extreme periods of heavy precipitation or drought, water has become even more important in our lives. If our descendants are to inherit a healthy environment, we must become infinitely better stewards of our land and water than ever before.

Luther Lake and swamp have created a biological oasis that is one of southern Ontario's most significant wetlands and wildlife habitat areas.

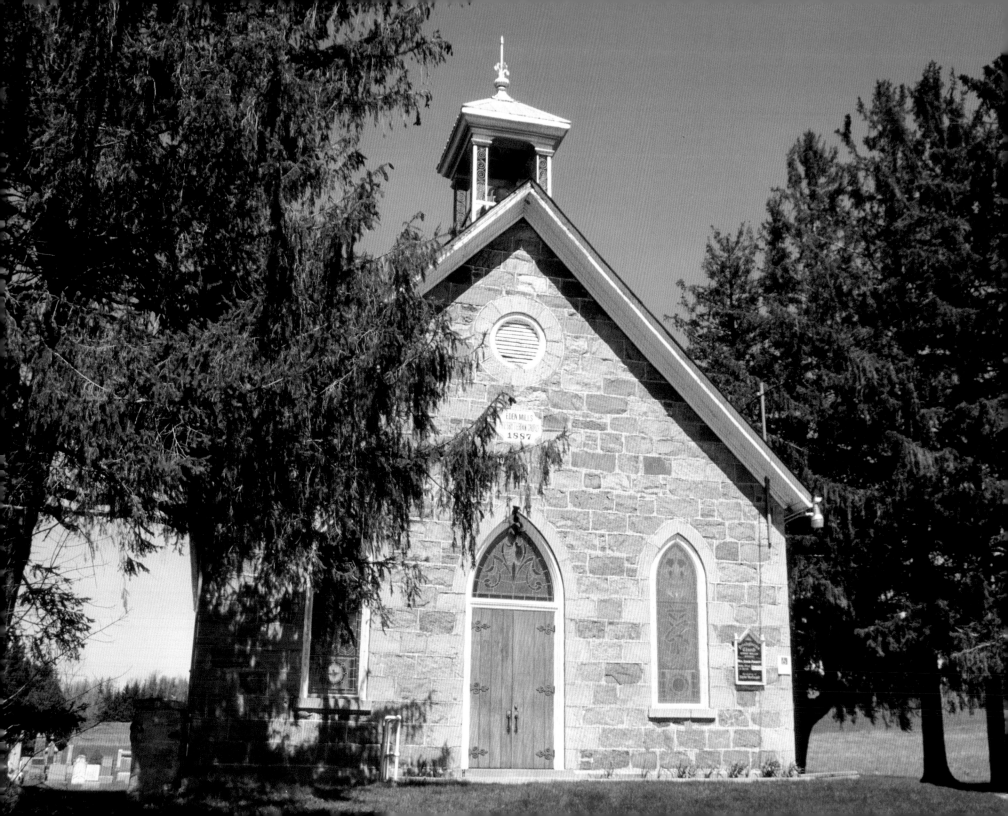

Building in Stone

PIONEERS ENTERING THE COUNTY along rivers and trails found the Guelph Formation of the Lockport Dolomite, an ideal building material of hard crystalline limestone. Over time, moving ice exposed rocky outcrops along the edges of cliffs, and torrents of milky water removed material from gorges, exposing the solid strata below. In locations such as the Rockwood Conservation Area, the gorges of the Grand and the banks of the Speed River, limestone lay waiting to be exploited. Settlers and builders quickly quarried these easily accessible outcrops, creating the impressive limestone structures that we see today.

Limestone Buildings in Guelph

As the founder of Guelph in 1827, John Galt imported skilled Scottish stonemasons to build his new community. By the 1850s Guelph was growing quickly, and earlier buildings of wood were being replaced by sturdy limestone structures. An increasing number of elaborate churches, business blocks and municipal buildings reflected the widespread use of limestone in the 1800s. Throughout the county, diverse homes, from tiny workers' cottages to ornate mansions and farmhouses, were being constructed from this easily worked material. Guelph and Fergus possess some of the most spectacular examples, but limestone buildings are found in many parts of Wellington County.

The city of Guelph, with approximately four hundred limestone buildings, outranks all Ontario communities except Ottawa in this respect. The historic ambience and character of contemporary Guelph continue to reflect the careful craft of early stonemasons and the imagination of well-known architects who built with limestone. Its unique main street architecture, its handsome municipal buildings, elaborate homes and gracious churches continue to reflect their skill and dedication.

Eden Mills Presbyterian Church, built in 1887.

Soon after he arrived, John Galt gave orders to acquire limestone for the building of a school and bank in his new community. The stone was to come from a quarry excavated when Waterloo Avenue was being cleared as the major road to Waterloo. In 1837 Emslie Quarries opened to provide stone to build the first municipal buildings on Douglas Street. The jail was completed in 1839 and the court house in 1843.

The Wellington County Court House now stands like a castle, displaying its crenellations and Scottish keep to Wellington Street through a screen of trees. It is the oldest remaining stone public building in Wellington County and one of the oldest stone buildings between Toronto and London.

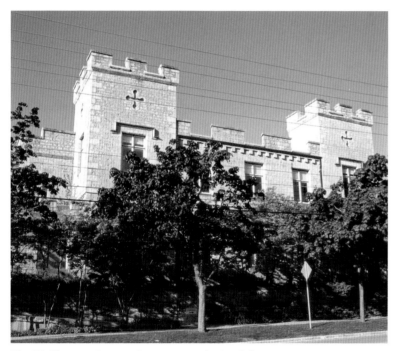

The Wellington County Court House in Guelph.

Today it houses the offices of the County of Wellington in the carefully restored original building and a tasteful addition.

The County Solicitor's building was constructed in 1865 and has survived with few alterations. This two-storey gem has quarry-faced blocks framing windows and doors, contrasting with a background of smooth masonry. Douglas Street, where it stands, could be a small alley on l'Isle de la Cité in Paris.

The delightful view along Douglas from St. George's Square towards the Speed River terminates at St. George's Anglican Church, another historic limestone landmark in Guelph. Archdeacon Arthur Palmer, its rector for many years, was instrumental in its construction in 1873. This venerable pastor lived across the river in Ker Kavan, his manse above the river on Stuart Street, and could walk to his church on a footbridge built for that purpose. The church is aligned so that its tower and soaring spire are framed by Douglas Street and are directly in line with St. George's Square. It is an outstanding example of an English Gothic parish church, complete with a rustic rough stone exterior and flying buttresses. Radiant stained glass windows, colourful roof slates and an excellent carillon place it among the most important buildings in the city.

By 1861 many architects and over fifty stonemasons were working on limestone buildings in Guelph. Guelph's Town Hall (now city hall) is an outstanding example of their mid-nineteenth century Renaissance Revival style. Standing in its own square behind a statue of John Galt, the city hall now dominates Carden Street. It was designed by William Thomas and constructed by local stonemasons in 1857. Its rooflines are adorned by gargoyles and other embellishments carved by Guelph's own Matthew Bell. This same master carver built the "House of Heads" at 40 Albert Street, a well-proportioned

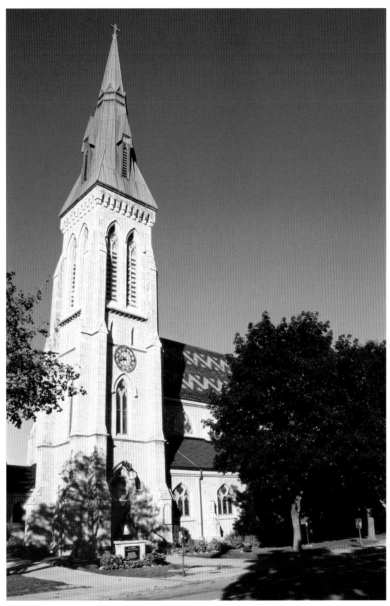

St. George's Anglican Church, another historic limestone landmark.

structure with carved window lintels, a framed central doorway and three carved stone heads that have been well preserved by subsequent owners. A large number of other homes such as Sunnyside and Wyoming were built for "leaders of the community" during the 1800s.

Before the turn of the century, a number of spacious stone churches were erected near St. George's Square. Overlooking Guelph like a medieval cathedral, the magnificent Church of Our Lady of the Immaculate Conception on "Catholic Hill" (the highest drumlin in Guelph) was begun in 1876. The site, considered the best in Guelph, was given by John Galt to his friend Bishop Macdonnell for his first church. Its spires and flying buttresses soar to the sky, drawing eyes upwards from everywhere in the downtown. To preserve the view, a bylaw prevents nearby structures from rising above its exquisite rose window. Its twin towers were not completed until 1926 because of a lack of funds, and today they are undergoing extensive renovations. Its cavernous interior has numerous examples of glorious religious art and is the venue of concerts as well as sacred services. The view of this church from the Guelph market is reminiscent of a medieval European city.

St. James the Apostle Anglican Church, built in 1891, and one of eight other major nineteenth-century churches built near the centre of Guelph, dominates the corner of Glasgow and Paisley Streets with its solid stone walls, tall pointed spire and ornate windows. The slate roof and diamond stained-glass windows add distinction to this handsome structure. St. Andrew's Presbyterian Church was built in 1859, Knox Presbyterian in 1869, and Chalmers United in 1870. A number of other interesting limestone churches such as Dublin Methodist and First Baptist were constructed slightly farther from the centre of town.

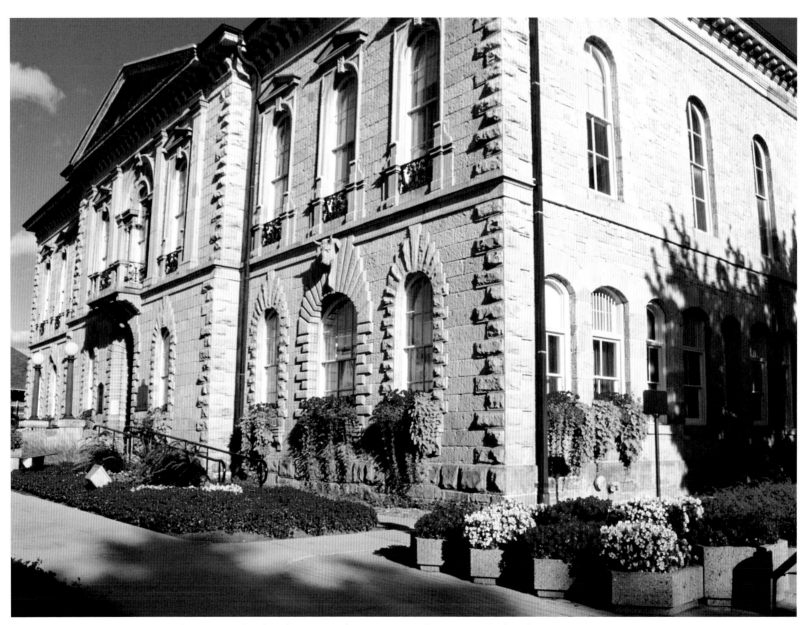

Guelph's city hall is an outstanding example of mid-nineteenth-century Renaissance Revival style.

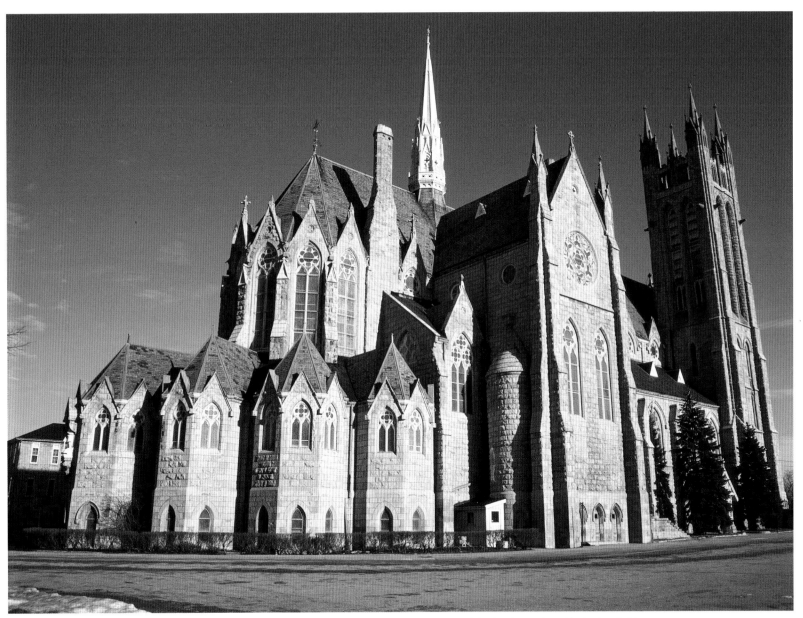

The magnificent Church of Our Lady of the Immaculate Conception on "Catholic Hill" (the highest drumlin in Guelph).

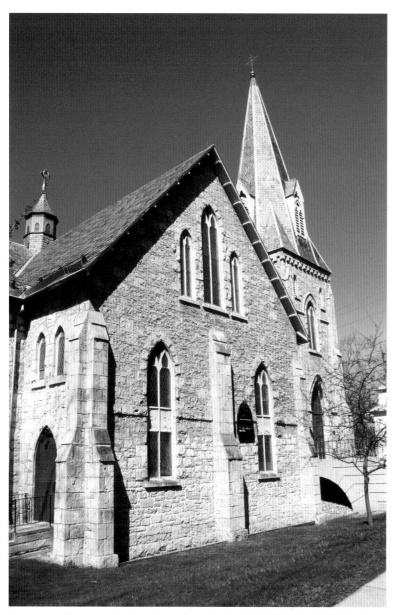
St. James the Apostle Anglican Church, Guelph, built in 1891.

In addition to churches and municipal buildings, a large number of palatial homes were designed for the leaders of the Guelph community, often complemented by tidy limestone workers' cottages nearby. Today even the smallest limestone cottages command premium prices because of their central locations, sturdy construction and heritage value. Inner Guelph has remained relatively compact, so many examples of outstanding limestone architecture are within a few blocks of St. George's Square. The local branch of the Architectural Conservancy of Ontario has had many designated as historically significant, and some areas of the city may soon be designated as Heritage Districts. Guelph's "limestone legacy" contributes enormously to the city's charm and to its relatively high prices for housing.

Fergus, Limestone Legacies

Next to Guelph, Fergus has the most impressive limestone architecture in the county. During the nineteenth century, skilled Scottish stonemasons built over 200 structures there. St. Andrew Street displays some of the finest examples of three-storey limestone buildings in Ontario. They remain as enduring monuments to the Scottish stonemasons who built the town. The Post Office, built in 1911, is a testimonial to the era when public buildings were symbols of civic pride. Its soaring clock tower dominates the corner, which is enhanced by its handsome rough limestone presence.

The Breadalbane Inn was built in 1870 just across Tower Street to the west. This restored former residence of the founding Ferguson family is now a small, intimate hotel. Its original owner, George Ferguson, insisted on being called

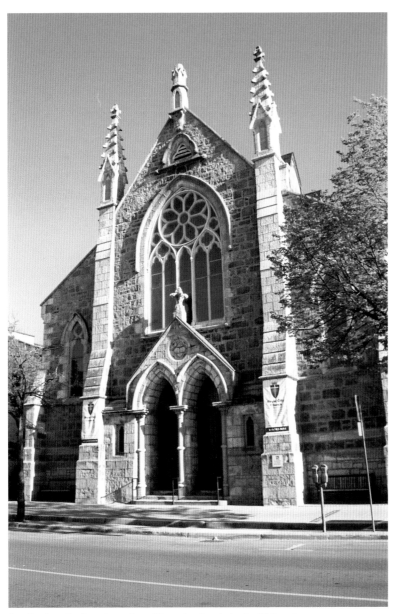

St. Andrew's Presbyterian Church, Guelph, built in 1859.

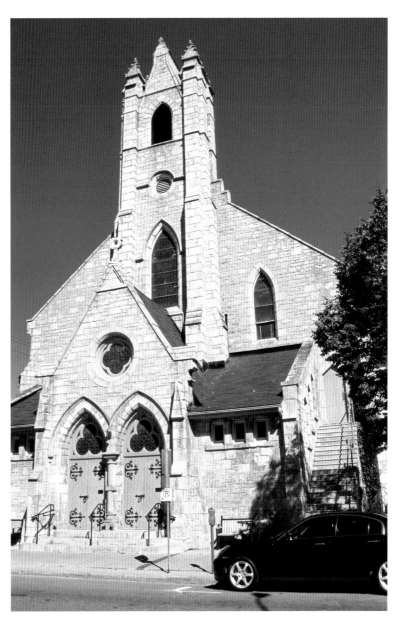

Knox Presbyterian, Guelph, built in 1869.

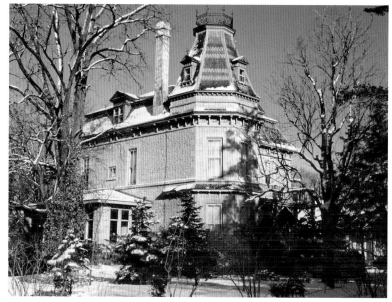

In addition to churches and municipal buildings, a large number of palatial homes were designed for the leaders of the Guelph community.

"Gentleman," rather than the banker that he was. In those days bankers were little respected as a group, and Ferguson`, who was known for "sharp practices," was less popular than most. Today the Breadalbane's superb dining room exudes old-world charm and its cozy outdoor pub evokes the atmosphere of Britain. The rock-floored, flower-festooned garden terrace and glassed-in atrium are favourites for fine dining. In front of the Breadalbane, a fierce, carved-wood Scottish warrior stands tall, brandishing his broadsword and round shield at all who enter.

Several spectacular stone churches dominate St. Patrick Street near Tower Street. The early rivalry between Catholics and Protestants is reflected in their history. Fergus founders Ferguson

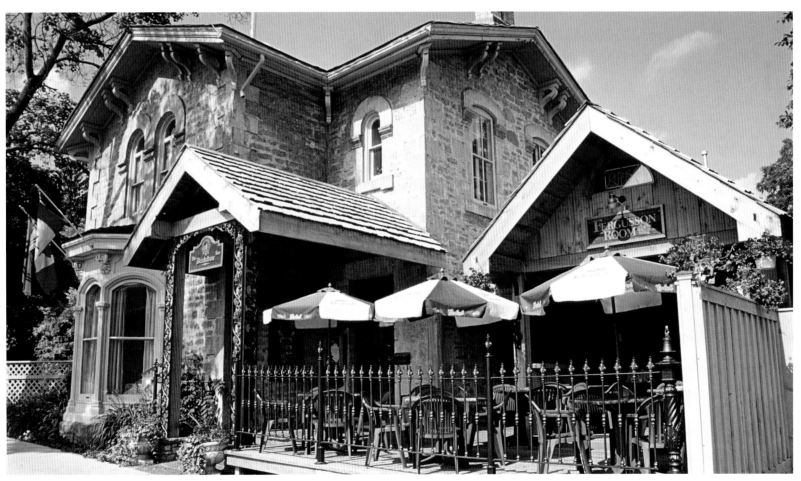

The Breadalbane Inn was built in 1870 for George Ferguson, son of the founder of Fergus.

St. Joseph's Catholic Church in Fergus, built in 1865, lost its steeple in 1913 during a vicious winter storm.

and Webster set aside land for all denominations but decided that a somewhat remote swamp would do as a site for the Catholic Church. The Catholics declined the suggested location and held out for the hill closer to the centre of town. St. Joseph's Catholic Church was eventually built there in 1865, but lost its steeple in 1913 during a vicious winter storm. Without its tall steeple, St. Joseph's became less top heavy, and appears vaguely Norman.

Nearby, St. Andrew's Presbyterian Church, built in 1861, overlooks the intersection of Tower and St. George Streets. Its rose window and steeple present an extraordinary vista to travellers from the south. Early in the day, rays of the sun evoke a spiritual impression when they glint off its rustic exterior. Behind the church lies the first burial ground of the village. Most early settlers were interred in the Auld Kirk Yard, but neither Catholics nor blacks were welcome. Originally Catholics were buried in plots near their church but in the early 1900s the site became a gravel pit and then a dump. The appearance of bones halted gravel excavation but left Catholics without a local cemetery. Catholic families often opted to bury their dead in Guelph, being prevented by civic rivalry and pride from using the cemetery in nearby Elora. Nevertheless, many early paupers were laid to rest in the Auld Kirk Yard with neither ceremony nor monument to commemorate their passing.

For those interested in municipal history, the old Council Chamber and Engine House stands at the north corner of Tower and St. Patrick Streets. This simple structure was originally a two-storey building, which has been maintained rather poorly. Its austere architecture reflects the frugal attitudes of the original Scottish councillors. Nearby in James Square, the "kissing stane" lies under the trees. It was a favourite meeting spot for young people who in Victorian times were allowed to kiss in public only if sitting on the "stane."

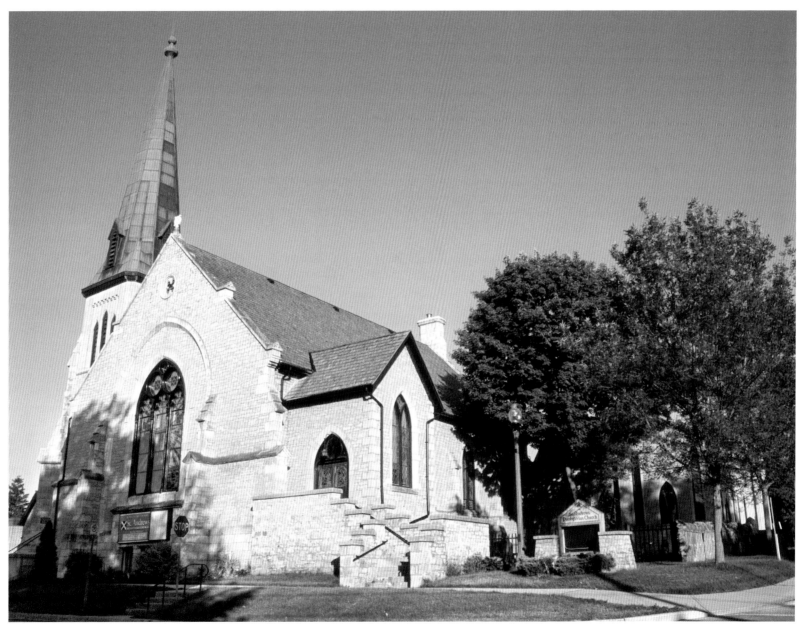

St. Andrew's Presbyterian Church in Fergus, built in 1861.

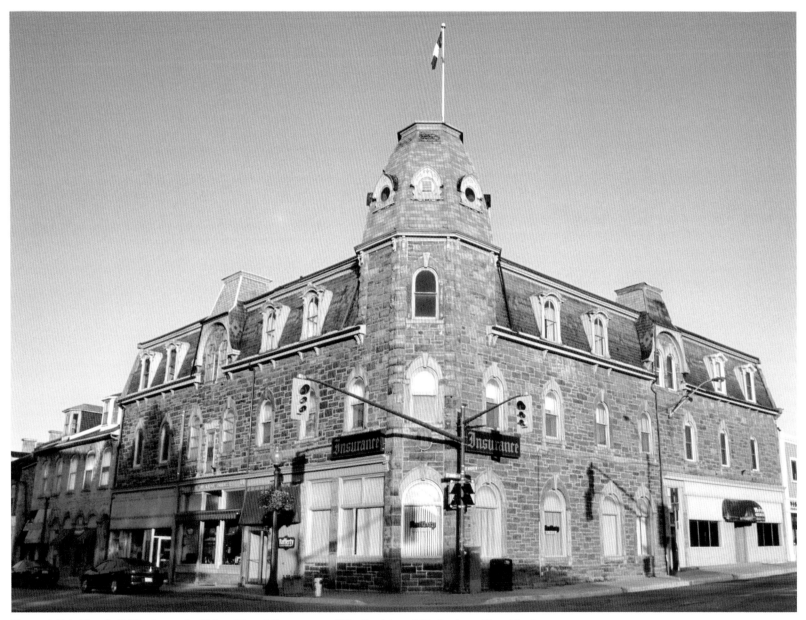

The reddish Marshall Block was built in 1880 at the corner of St. David and St. Andrew Street in Fergus.

St. Andrew Street

A walk to the corner of St. Andrew Street and Provost Lane presents a stark contrast to the plain civic building above. The business architecture created by early entrepreneurs was considerably more ornate, reflecting the prosperity of nineteenth-century Wellington County. East along St. Andrew Street, the summits of historic buildings have date stones commemorating their construction. Their rooflines and window frames are often outlined in ornate limestone.

The reddish Marshall Block built in 1880 at the corner of St. David and St. Andrew Streets is faced with the local Credit Valley sandstone, which became fashionable at the turn of the century. In the morning it takes on a distinctive reddish hue and its circular tower dominates this major intersection. The Argo Block across the street is one of the best examples of Ashlar limestone in Fergus. Its finely cut limestone front is a masterpiece of careful

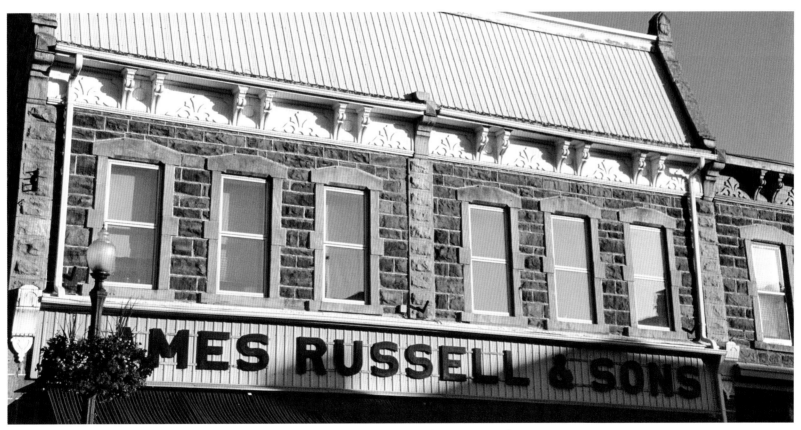

Russell Block on St. Andrew Street in Fergus is an excellent example of meticulous stonework.

Scottish masonry. This was much more difficult and time-consuming to build than the usual rubblestone sides and backs of other buildings. A peek behind most structures along the main streets reveals the frugality and ingenuity of the Scottish builders of Fergus who decorated only the front facades.

The prosperous main street of Fergus reflects its importance as a local market town and service centre. Despite some modern "improvements" to shopfronts, St. Andrew Street would not be out of place in Scotland. On the north side of the street, east of the modern Canada Trust building, the Russell Block and Commercial Hotel Building are excellent examples of meticulous stonework. After several renovations, both were faced with Credit Valley sandstone in the 1880s. The former Egg Emporium is to the south from 216 to 224. Here eggs were sorted, pickled and stored. Its facade has changed little over the years. The interior of James Russell and Sons with its rustic wooden floors and shelves remains much as it was from the beginning. After several limestone blocks burned to the ground, it was impossible to reconstruct them of stone. Prohibitive costs and the scarcity of stonemasons dictated less elegant modern replacements.

The massive well-preserved Monkland mills rise majestically above the Grand River, overlooking their original dams at the eastern extremity of town. On a fine summer day, groups of artists painting and sketching become part of the scene. By the dam several fishers angle for brown trout in what has become one of the best catch-and-release trout streams in North America. The mills are a reminder of the prominent importance of wheat and water, streams and dams to the economy of early Ontario. These solid buildings dating from 1835 have recently been converted into modern condominiums catering to retirees and persons who love small towns.

Many of the older limestone houses in Fergus have been designated as architecturally significant and bear plaques indicating the names and occupations of their original owners. A stroll along several of the streets north of and parallel to St. Andrew is rewarded by the sight of these interesting historic structures. Fergus does not exhibit as many palatial structures as Guelph, but its more modest homes are a treasure trove of local history.

The Wellington County Museum and Archives

The road from Fergus to Elora follows the Grand River past the former Wellington County House of Industry and Refuge, now the Wellington County Museum and Archives. This imposing limestone building, with its red roof and soaring cupola, dominates a hill overlooking the river. It was opened in 1877 as a temporary home for 65 "inmates" who were too old or poor to work. In those days, every county with a population over 20,000 was required to have a "poorhouse" for people who were destitute. Families of transient labourers who fell ill and could not work crowded the facility. Women and children lived apart from the men. Each group had its separate staircase.

Originally, the intent was that residents would work on the farm beside the building, but it was impossible to require the sick and old to toil in the fields. By 1900 the building functioned primarily as a home for the elderly, and became the Wellington Home for the Aged in 1947. Subsequently, it was named Wellington Place but closed permanently in 1972 when it was slated for demolition. At this time local historians and preservationists rallied to save one of the most impressive structures in the county. They convinced officials to move the

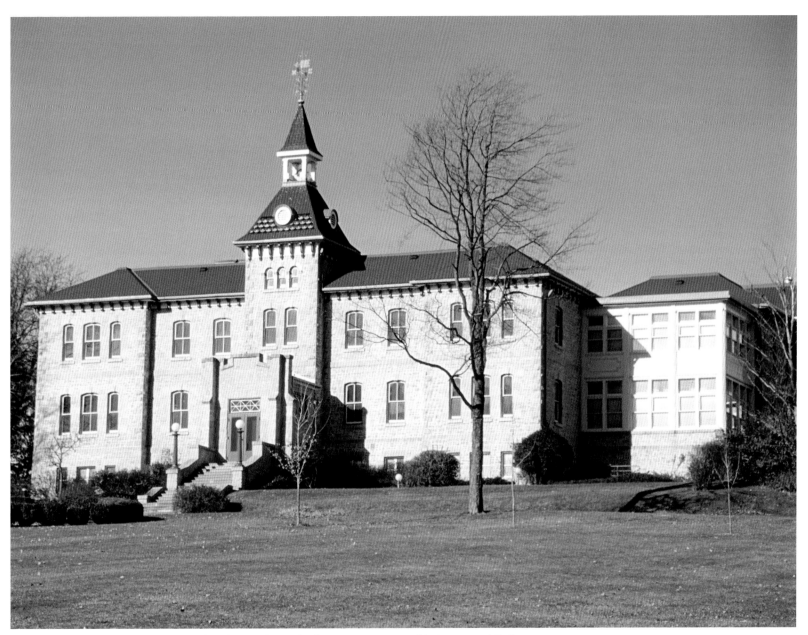

The Wellington County Museum and Archives, formerly the County House of Industry and Refuge.

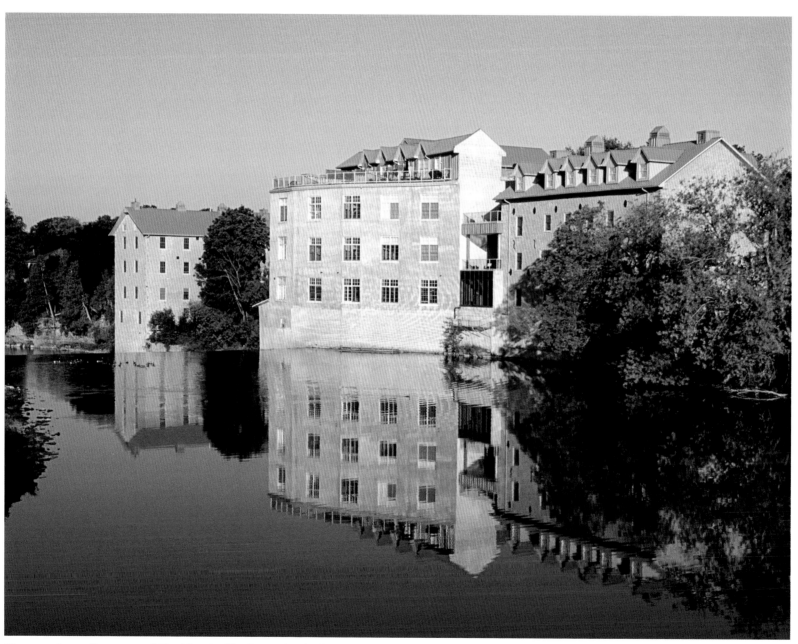

The massive well-preserved Monkland mills rise majestically above the Grand at the eastern extremity of Fergus.

Wellington County Museum and Archives from Elora to Wellington Place, where it has remained. Today the long ward hallways and attractive rooms are home to over 14,000 artifacts, which are visited by thousands of people each year.

History seemed to have come full circle when a new home for the elderly was built on the adjacent property.

Limestone Buildings Elsewhere

None of the other municipalities in Wellington display as many diverse limestone buildings as Guelph or Fergus. Nevertheless, excellent examples of the art of the stonemason exist in rural schools, churches, houses and small business blocks. The ubiquity of limestone in Wellington made it possible to quarry this popular and durable building material in many other locations and to build there also.

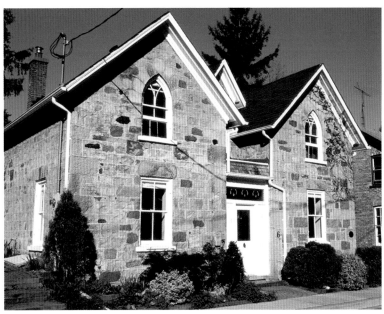

Some houses display limestone and igneous rocks on their facades.

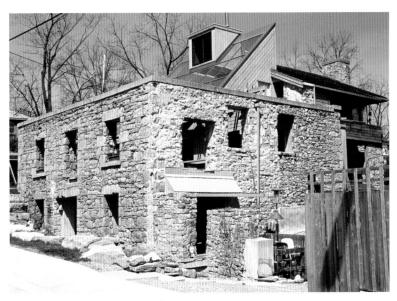

Former grist mill in Eden Mills.

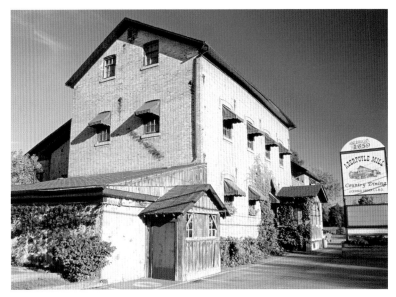

Aberfoyle Mill.

55

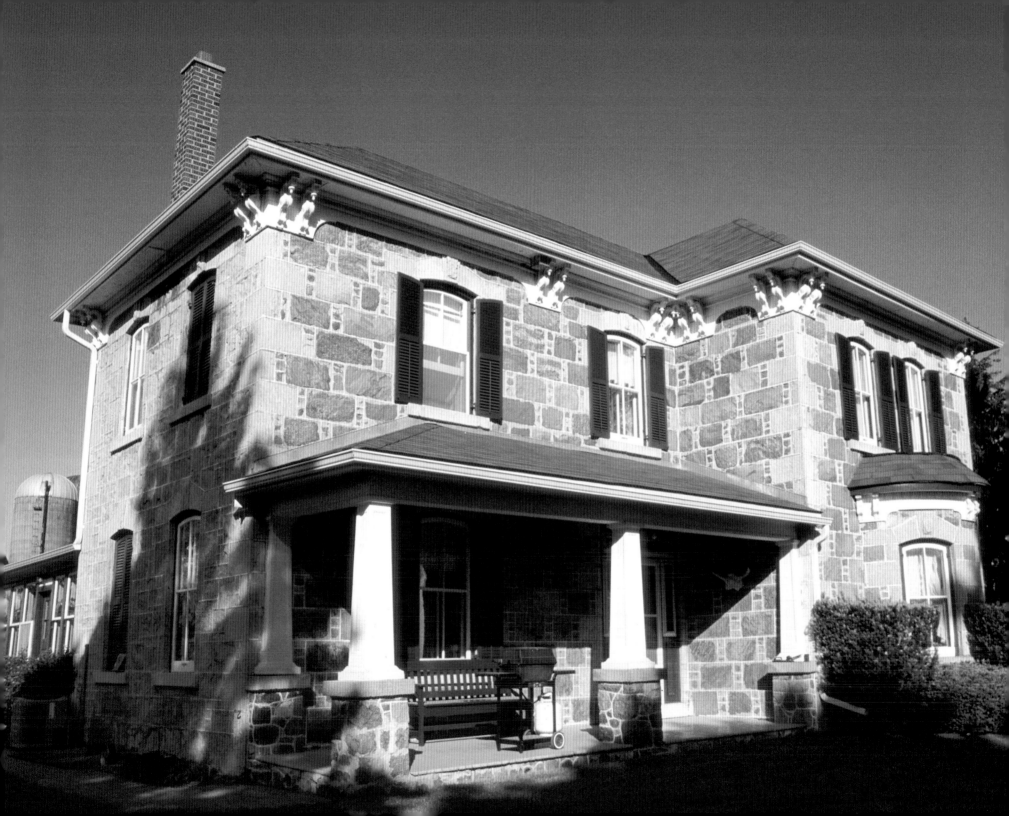

The Changing Rural Landscape

Donald and Joyce Blyth are the proud owners of a century farm that has been in the family since 1863. Their reminiscences and a stroll around Blythwood's 54 hectares (134 acres) graphically illustrate the history of agriculture in Wellington County. The Blyth's gracious limestone home stands at the end of a long lane lined with magnificent spruce trees. Behind the house we find a driving shed and an L-shaped bank barn flanked by tall concrete silos. Here, Donald, his father, his grandfather, and his great grandfather toiled for 144 years. During that time they experienced numerous changes in agricultural practices. Their traditional mixed family farm eventually evolved into a modern cash crop operation.

Agriculture in Wellington County has become big business, but this was not always so. Original 40-hectare (100-acre) family farms have been replaced by factory farms requiring much more land. Horses and wooden plows have given way to massive tractors and harvesters. Long steel sheds stand beside traditional wooden barns. Today fewer farmers produce greater yields on less land than ever before. Recently, Wellington County ranked eighth among the fifty-three Agricultural Regions in Ontario. Its annual gross farm receipts were about $434 million. The history of Blythwood is one of persistence.

In the early 1800s hardy English and Scottish settlers came to Wellington County seeking land and opportunities. When they eventually found their property, the first order of business was to clear a space and construct a shelter. This was usually a one-room cabin built of logs cut by hand with axes and saws. Their first year was inevitably one of unremitting labour and loneliness. Dark, oppressive forests and isolation added to their misery. In 1832, Donald's great grandfather, Alexander Blyth, and his three brothers left the family brass foundry in Glasgow to try their luck as pioneers in the new

The Blyth's gracious limestone home stands at the end of a long lane lined with magnificent spruce trees.

world of Upper Canada. They purchased land just north of where the Owen Sound and Woolwich Roads met and built the first hotel in Guelph Township.

In 1834 Alexander married Janet McDonald. Together they raised nine children, six sons and three daughters. In 1863 Alexander bought the land that became Blythwood, which he farmed until 1872. Then his son Robert took over. He worked the land successfully until 1898 when he was gored to death by a bull. Robert's son Colin continued the business until 1953. Since then, Donald and Joyce have maintained the tradition by living on the property and running the farm.

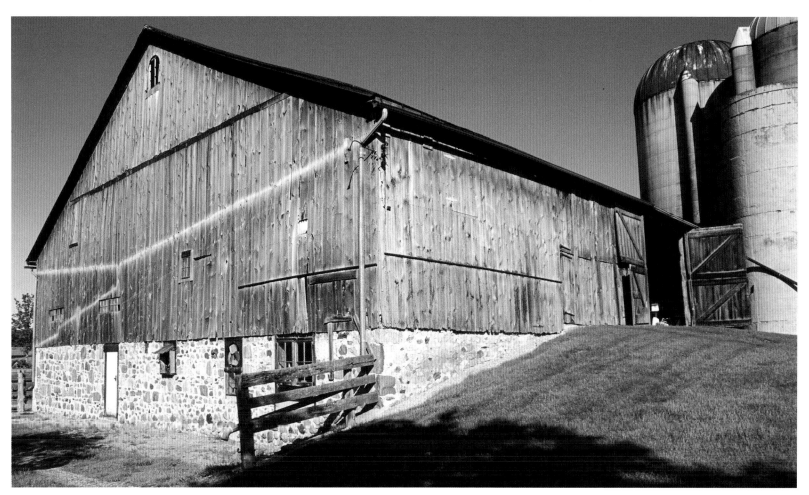

Behind the Blyths' house are a driving shed and an L-shaped bank barn flanked by tall concrete silos.

At the beginning the Blyths endured many hardships. Dense forests with trees up to 30 metres (100 ft.) tall and several metres around were difficult to clear. The massive trees were thinned by a process called girdling. This was achieved by cutting strips of bark to prevent sap from rising in the trunks. After the leaves had fallen, the first crops were planted in the loose soil below, nurtured by the light filtering through the branches. These first farmers had only simple implements such as spades, hoes and rakes to cultivate their clearings.

While the Blyths laboured to establish a farm, native grasses, flowers and bushes constantly threatened to choke their land. The scene was an untidy mix of underbrush, trees, stumps and crops. Until cisterns were built or wells were dug, they collected drinking and washing water from lakes or streams. For the first year or two, everyone struggled to survive in the wilderness.

When enough land had been cleared for a kitchen garden, the Blyths cultivated raspberries, strawberries, potatoes, carrots, lettuce, squash and beets. Eventually they had cut enough of the towering trees to prepare fields for the cultivation of oats, barley, wheat and turnips. An orchard was established with two rows of trees bearing spy apples and pears. As time passed, blackberries and wild shrubs sprouted along the split-rail fences between their fields. In the early days vegetables were stockpiled for the winter in a cold storage cellar under the workshop. Their main source of income was from the sale of Scottish Shorthorn cattle to be used for breeding. For their own consumption they killed a pig or two each year. Some of the pork was cured for ham and the remainder was made into headcheese or sausages.

When all the land except the back field had been cleared, they hired two Scots having no experience with axes to remove the bush. After a difficult summer of long, hard days their Scottish workers became proficient farmhands. They preserved only the stands of large trees that border the property and 6 hectares (15 acres) of bush at the rear. In thirty years the Blyths and their workers had transformed the wilderness into a typical mixed family farm.

The first house on the property was a log lean-to, followed by a small stuccoed dwelling. The gracious home that we see today was built of local limestone in 1888 by contractor Dave Young. It has six bedrooms and a full basement. The front features a bay window and a verandah. The enclosed side porch serves as a sunroom and sheltered entrance to the kitchen. The Blyth homestead is an interesting and eclectic combination of Regency and Italianate architecture.

The large Central Ontario bank barn was built in 1884 to replace its smaller two-bay predecessor. Its location on a small hill allows direct entry to the stables below and to the drive floor above. The skeletal head of a deer greets everyone approaching the building. Inside, there are wooden rack lifters used to hoist wagon racks loaded with hay or straw up to the mow.

An L-shaped addition was built later to increase the space to accommodate 60 to 65 Scottish Shorthorns. These were nurtured by Colin who specialized in raising purebred cattle to be sold for breeding. In 1938 his bull won the grand prize for Shorthorns at the Chicago International Exposition. During this period both the farm and Colin prospered. Blythwood was renowned for its excellent livestock and its owner became president of the Shorthorn Association.

Electricity came to the area in 1928 but the lines ended at Marden, so Colin paid to have them extended to his farm. Life became much easier for everyone, especially his wife who had previously relied upon wood stoves for heat and cooking and for boiling water to launder clothing. Before electricity,

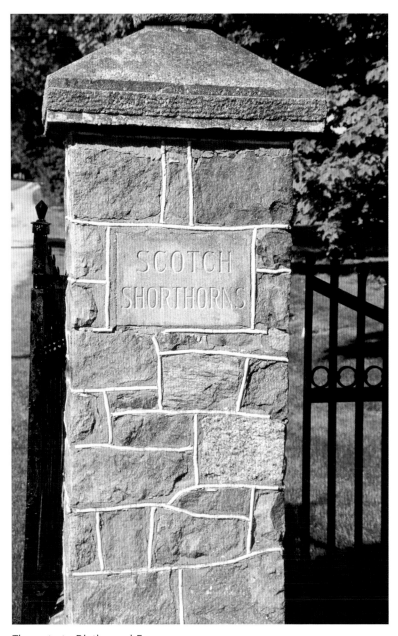

The gate to Blythwood Farm.

clothes were washed by hand, and cold cellars were used for food storage. Electric stoves, washing machines and refrigerators became indispensable for farmers' wives, but most continued to make soap, bread and butter at home.

Another new invention, the gas engine, became available in 1910. As a result the Blyths purchased their first tractor in 1920. They continued to cut, stook, load and move grain for barn threshing by hand until about 1932 when they acquired a threshing machine. Nevertheless, they continued to use horses for most chores except plowing and cultivating until 1951. In 1948 Colin, who was a board member of the company, purchased the world's first home freezer from W.C. Wood in Guelph. This cumbersome box, insulated with cork, was never mass-produced because of its prohibitive cost. It served efficiently for many years in the Blyth's cellar, where it now functions as a table.

Until 1956 the family sold its prize Shorthorn bulls to breeders or farmers, but the advent of artificial insemination reduced demand for this service. For a while their stock continued to provide semen for sale, but the Blyths could not compete with Semex, a mass producer and supplier of this commodity. Donald and Joyce adapted by establishing a feedlot where they fattened Hereford or Angus crossbreed stocker cattle. These were fed until they reached 545 kilograms (1,200 lbs.) when they were sold for slaughter. Changing markets and agricultural practices had forced several generations of Blyths to transform their business from a typical mixed family farm into a modern feedlot operation.

Today Donald and Joyce practice "custom farming." They buy seed that is sowed and harvested by a neighbour for a per-acre charge. Their crop rotation consists of two years in soybeans to each year in wheat. The 44 hectares (108 acres) being cultivated produce up to 6.6 tonnes per hectare

(98 bu. per acre) of hard red wheat, a very respectable yield. In 144 years, Blythwood, like many other farms in the county, has come full circle from subsistence farming to a small cash crop operation.

The Blyths have every intention of keeping their land in the family as long as their children are interested. Sadly, many rural traditions such as monthly dances in the schoolhouse, close association with neighbours, farm forums and Saturday card games have long since disappeared. Fortunately for the Blyths, their home is isolated enough to provide privacy but is easily accessible to all the attractions of Guelph. Despite the trend to mass production and factory farming, the Blyths have maintained their rural heritage in Wellington County.

Modern Pioneers

A few kilometres away on the Fourth Line of Eramosa Township, John and Marcia Stevers operate Blue Haven Farm. In 1995 they purchased 4.05 hectares (10 acres) of wetland to fulfill their dream of a simpler life in the country. This was to come true, but only after they had drained the land, prepared their fields and constructed some buildings. For three months they lived in a tent on the land while working full time in Toronto. On weekends they toiled to establish a garden and build a home for their family. Then they constructed a small barn and fenced plots for their pigs and poultry. The pigs did double duty as food recyclers and "root-a-tillers," clearing weeds from ranges where ducks and turkeys were to roam. All the while the livestock had to be protected from the constant threat of coyotes, skunks, possums, raccoons and owls.

Marcia is in charge of daily operations while John continues his full-time job, a typical arrangement for part-time farmers. In Marcia's own words: "Our daily activities include milking our goat and making yogurt and baked goods; gathering wild fruits and berries; canning, preserving, making homemade bread, cooking all our meals using mostly all our own produce; and building necessary items such as chairs, stands and fences. We are tied to the farm but life has never been richer. We are glad we made the move. Eating a homegrown dinner by homemade candlelight will make anyone envious."

After years of backbreaking work, John and Marcia began to produce a surplus to sell. Their Ameraucana chickens lay delicious eggs with vivid yellow yolks and shells that vary from green to blue. Their Jerusalem artichokes, several varieties of garlic, tomatoes, popcorn, watermelon, rhubarb, onions and herbs are all grown organically. A flamboyant ostrich struts around its outdoor pen, fanning a colourful tail while competing with the handsome Tom turkeys displaying their quivering red wattles. Small, white Silkie chickens with fluffy crests on their heads scamper about their enclosures.

Their snowy geese share space with plump Muscovy ducks, which Marcia says are neither duck nor goose but do produce delicious lean meat. Mabel and Daisy Mae, the nanny goats with stringy beards and strident "baaing" voices, provide milk for the family and amusement for their youthful guests. Most of the animals on the farm have become pets as well as potential sources of income, making it sometimes difficult to take them to slaughter. At any time there are between 275 and 1,000 birds on the premises, breeding, laying eggs or being fattened for market. After years of struggle and dedication, John and Marcia have realized their dream. They love their life and enjoy selling their produce from the farm and at the Guelph market.

Stevers' Ameraucana chickens are free to range about their enclosure. Ameraucana chickens lay delicious eggs with vivid yellow yolks and shells that vary from green to blue.

Goose and goslings on Stevers' farm.

The Mennonites

In the 1960s land speculation, demand for hobby farms and rapid urbanization made it too expensive for young Mennonites to buy land in Waterloo County. As a result, some Old Order Mennonites moved from Waterloo County to the Arthur–Mount Forest area of Wellington County to establish new farms and to preserve their way of life. These farms continue to reflect traditional Mennonite culture and agricultural practices.

Old Order Mennonites use neither electricity nor mechanized implements, so their farms, which have no hydro wires to the road, are easily identified. Their farming is labour intensive, using horses and human energy rather than machinery. This results in a distinctive landscape and in extremely efficient farming practices. The Mennonites' heavy use of animal manure instead of chemical fertilizers is economical and environmentally friendly. Because of their intensive methods of cultivation, Mennonites continue to enjoy some of the best crop yields in Ontario.

The oldest order Mennonites are distinguished by their plain clothes with hooks and eyes instead of buttons. On Sundays men wear black suits and hats, while women in long black dresses cover their heads with black bonnets. Mennonite farmers advertise summer sausage, maple syrup and eggs for sale on their farms, but never on Sunday. Their unadorned churches with hitches for horses and simple white schools contrast starkly with modern counterparts.

Whether they are farming, selling produce in Mount Forest or driving to town in their buggies, Mennonites contribute their distinctive culture and sustainable agriculture to northern Wellington County. In addition to being a highly visible minority, they are ambitious, industrious and honest, a major asset to any community.

Modern Survivors

Several mature bull elk with massive sprawling antlers range tall and majestic across a field at Eramosa Elk Enterprises on the Fifth Line of Eramosa Township. This modern, 40-hectare (100-acre) farm is owned and operated by Bernie and Martha Schatti who purchased their first elk in 1994 when the market was hot. During the last ten years, the value of elk breeding stock has declined steadily. Trade barriers have sharply reduced returns on antler velvet, and the fear that they may carry "mad cow disease" has decreased demand for live elk.

Producers are now forced to market their animals as an excellent red meat alternative, with the result that many have struggled and some have gone out of business.

Life on an elk farm is not easy. Martha and Bernie work over 70 hours a week. During the summer they and their children labour from dawn to dusk. Martha's tasks include feeding friendly calves from a bottle and managing the retail store on their property. Bernie plows the land, sows seeds, harvests crops and tends the animals. Occasionally, he and the children take visitors for a tour on their trailer to safely view mature bulls on the land.

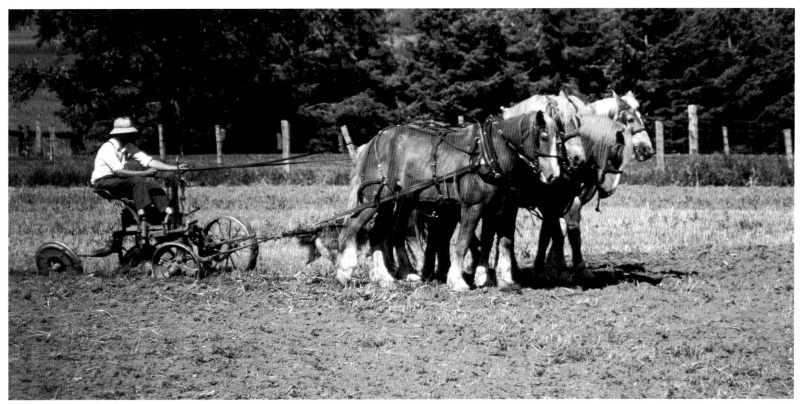

Mennonite farming is labour intensive, using horses and human energy rather than machinery.

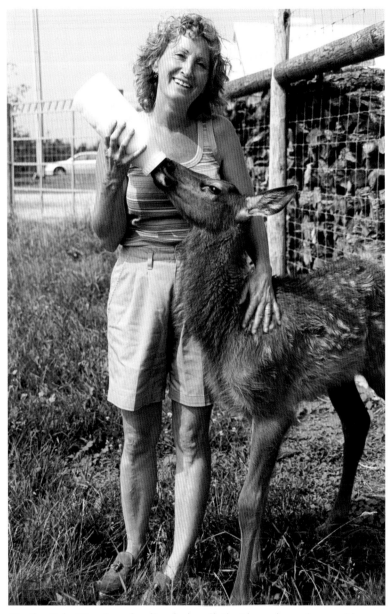

Martha Schatti enjoys feeding baby elk that have been ignored by their mothers.

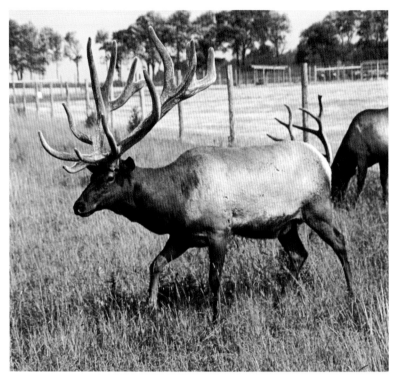

Several mature bull elk with massive sprawling antlers range tall and majestic across a field at Eramosa Elk Enterprises.

Their breeding program produces about 40 calves a year. Mature animals are slaughtered by a butcher who freezes or dries the flesh and packages it for retail. Martha sells the dark, nutritious meat at the Guelph market and from the farm. Their elk antler velvet is processed and retailed as a natural remedy for arthritis and other complaints. Despite changing demands and falling prices for their products, Bernie and Martha have survived in a difficult market with a herd of about 200 elk. Their efficiency, modern equipment, hard work and determination have enabled them to continue in the business that they love.

An Agricultural Anomaly

Kamil and Jerry Trochta came to Guelph in 1968. In 1981 they established Kamil Juices to import and distribute grape juice. Soon they were retailing locally and wholesaling to winemakers and winemaking shops across North America. For years they had owned farmland in a sheltered valley on Road 22, just off Highway 6 between Guelph and Fergus. In 1998 they decided to begin a winery on this land. Kamil and Jerry felt that there would be a market for locally produced fruit wines, so they augmented the apple orchard and planted 1.2 hectares (3 acres) of black currants. With great optimism, given the local climate, they also established a vineyard with 1.5 hectares (3¾ acres) of Baco Noir and hybrid Riesling cross grapes. Thus

Victoria and Jerry at Cox Creek Cellars on Road 22 near Guelph.

Cox Creek Cellars was born, continuing a tradition established many years earlier by their Czechoslovakian grandparents.

Cox Creek winery is something of an anomaly as far north as Wellington County. Its attractive tasting room displays a variety of wines made from apples and currants grown on the property. At the bar you can sample excellent Baco Noir and Riesling cross wines from their own grapes. In years when hard frosts reduce local yields, the Trochtas purchase grapes from the Niagara Peninsula to produce Merlot, Pinot Noir and Chardonnay. A knight in full armour oversees the sales room, which is ringed by attractive racks of wine for sale. Wines are available by the glass or the bottle at the winery, and are featured at several local restaurants. On weekends the Trochtas host weddings, barbecues, banquets and wine tastings on their lush wooded property.

Cox Creek Cellars is an exotic and welcome addition to the agriculture of Wellington County. Despite less-than-ideal climatic conditions, it continues to thrive. Cox Creek Cellars has won 104 medals for fruit and grape wines in national and international competitions. Like the Schattis with their elk and the Stevers with their produce, the Trochtas have fulfilled their dream of pioneering an innovative and successful agricultural enterprise in Wellington County.

Diversity in the Countryside

The Blyths, Stevers, Schattis and Trochtas represent the majority of farmers in Wellington County, but account for only a small proportion of its area and agricultural production. Small operations have long since been consolidated into massive factory farms producing milk, beef, hogs, poultry and eggs. Cash

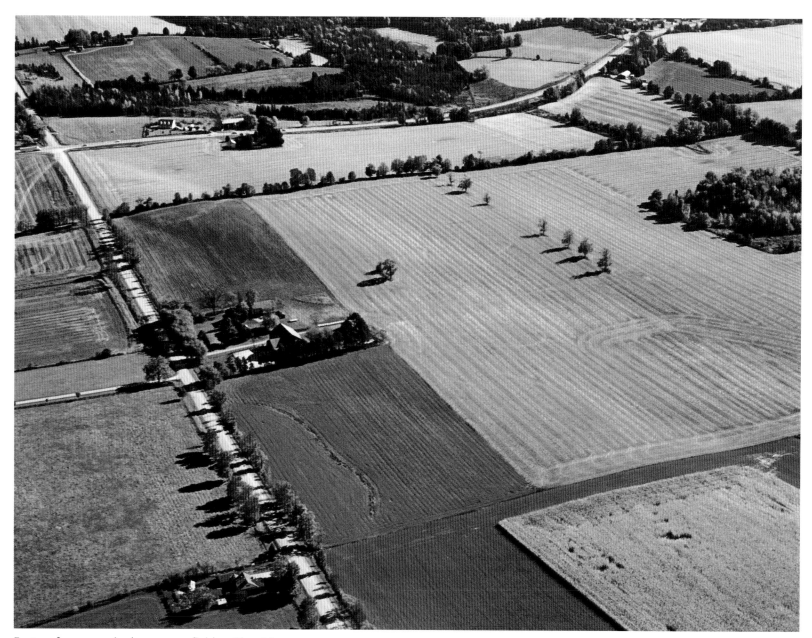

Factory farms require large open fields without fences.

In the summer, rippling yellow canola blossoms add a touch of colour to the scene.

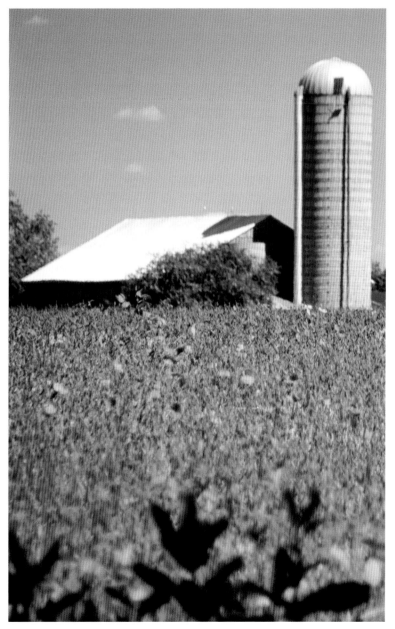

In the fall, squat rusty gold soybeans, ready for harvest, quiver in the wind. On the horizon, towering silos stand like sentinels.

crops are dominated by corn, soybeans and wheat. Together these enterprises account for most of the agricultural land and production in the county. Commercial agriculture and factory farms require large-scale enterprises with wide-open fields but few human employees. Consequently, farm populations have declined and some historic rural traditions have disappeared.

Large expanses of Wellington County have become reminiscent of the prairies. Since most animals are housed and fed in specialized buildings, fences are no longer required to protect the crops. In the spring, sweeping vistas of green corn or wheat stretch as far as the eye can see. In the summer, rippling yellow canola blossoms add a touch of colour to the scene. In the fall, squat rusty gold soybeans, ready for harvest, quiver in the wind. On the horizon, ranks of towering silos stand like sentinels against the clouds. Commercial farmsteads are generally neat and well kept, with tidy, brightly painted buildings surrounded

Beef cattle in front of a Pennsylvania barn.

by acres of smooth green lawns or carefully tended flower gardens complementing the crops in the fields.

Most commercial farms are located in prosperous areas with level fertile land such as Guelph, Pilkington, Maryborough and Peel Townships near the centre of the county. There, pigs are raised in long, one-storey barns, built well away from the house because of their strong odours. The roofs are punctuated by frequent vents to release the heat and stench produced by the rapidly growing hogs. Poultry are housed in similar metal structures several storeys high. Beef cattle on feedlots are housed in open metal sheds surrounded by silos filled with fodder. Nearby, shiny new seed cleaning depots and conical mechanized storage facilities dot the countryside.

In the background, older Central Ontario barns remain to store machinery and feed. Where dairying is important, the Wisconsin barn promoted in the 1890s by the Ontario Agricultural College for "scientific agriculture" continues to be used. It is distinguished by rows of windows, numerous vents on its gambrel roof and spacious milking parlours. Together these establishments on their vast tracts of land represent the face of modern agriculture in the county.

A number of successful businesses have been established in central Wellington County to serve commercial farmers. In 1982 Peter Hannam, a graduate of the University of Guelph, anticipated a demand for soybeans and founded First Line Seeds. As president, he supervised the research and development that created a variety of high-yielding, cool-climate soybeans that would thrive in Ontario. As a result of his vision and drive, First Line has become one of Canada's major soybean seed suppliers. Today soybeans are Ontario's largest field crop, covering some 971,000 hectares (2.4 million acres) of farmland.

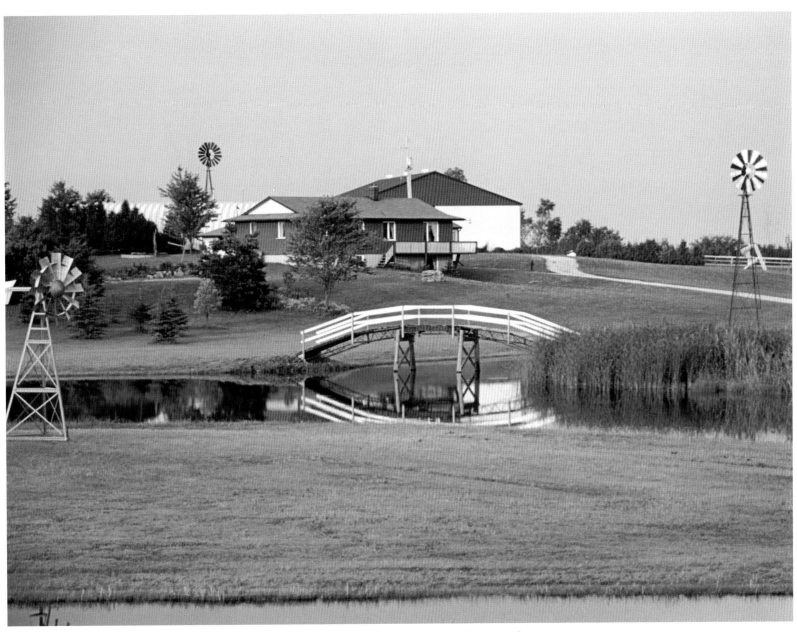

Many of Wellington's rural roads are lined with carefully manicured hobby farms and homes of commuters.

A drive through Erin Township leads to Christmas tree farms.

Gencor is a member of the Semex Alliance, which was established to market high quality cattle semen to breeders. Today Gencor owns 300 hectares (750 acres) in Guelph Township, where it grows feed for its 550 bulls. Using semen that they have produced, its network of technicians inseminates 290,000 cows a year and delivers products to dairy farmers who inseminate their own animals. Semex and First Line epitomize the scale of agricultural service activities in Wellington.

Other parts of the county are distinctly different from the prosperous central areas. Much of Puslinch Township is rocky moraine interspersed with cedar swamps, gravel pits and small kettle lakes. Many of its undulating tree-lined roads are flanked by rambling bungalows or ornate, gated mansions reminiscent of Italian villas. Several lush green golf courses are draped across its hills and dales. A large proportion of Erin Township is rugged or swampy, its sweeping vistas of forest, farm and fields inviting nonfarm development. In the autumn, vivid mosaics of red and yellow leaves stretch for kilometres from the peaks of its cigar-shaped drumlins. A drive through Erin Township leads to Christmas tree farms, hobby farms where sheep, goats and ducks are raised, and modern rural residential estates nestled among the trees.

At the northern end of the county, West Luther Township is too cool for grain corn or soybeans. Here, traditional agriculture on 40-hectare (100-acre) family farms remains important. Older two-bay or Central Ontario barns with wooden silos or windmills may still be seen. Long, narrow drainage ditches reflect the difficulty of cultivating territory laboriously reclaimed from the vast local wetlands. The Luther Marsh remains as a remnant of the dense vegetation and soggy soils encountered by the colonists. Some of this sparsely settled township reminds us of a pioneer fringe.

Specialty Agriculture

In rocky, rolling moraines or woodland, riding stables and horse-boarding operations are distinguished by their orderly white fences, horse jumps, trotting ovals and carefully landscaped property. Elsewhere, small specialty operations where customers pick their own produce are popular. In the spring, stooping figures are seen carefully plucking strawberries from long, lush rows. Later, they return to pick raspberries or perhaps to select a heavy, orange pumpkin from the field.

Several enterprising farmers have constructed complex labyrinths in their cornfields, enticing children to enter and explore. Others offer rides on horse-drawn hay wagons or sleighs. A few sod farms, rivalling golf courses for level, immaculate grass, provide instant lawns for the suburbs.

Sheep and goats abound on Wellington's many hobby farms.

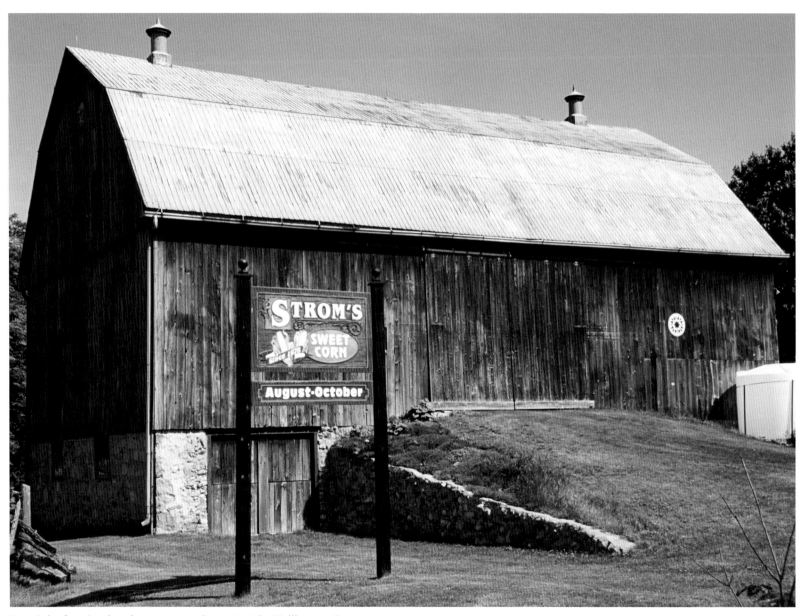

Specialty farming has become very important in Wellington County.

Rural greenhouses and nurseries supply everything from garden herbs and flowering plants to Christmas trees and free advice on gardening. Recently, increasing numbers of farmers have responded to health-conscious consumers wanting organically grown produce. Many chemical-free fruits and vegetables are now available at local markets and shops. Agriculture and rural land use in Wellington County are both complex and diverse. They have evolved to reflect its varying landscapes and the changing preferences of consumers.

Unfortunately, farming is no longer profitable for many rural residents. It has become a way of life to be preserved, as by the Blyths, or a hobby supported by off-farm income, as by the Stevers. Part-time farming is widespread. Off-farm employment by family members sustains hundreds of farms with marginal agriculture. Some rural residents operate school buses, graders or snowplows, and others work in the city. They remain on the land because they love it and their rural way of life. Others are artists, writers, retirees or artisans who prefer the tranquillity and inspiration of their bucolic environment. Often, their well-groomed lawns, freshly painted buildings and colourful displays of flowers reflect their dedication to the countryside.

The diversity and complexity of Wellington County may be seen everywhere in its buildings and on its landscape. Across the county, exclusive residential subdivisions and cottages have been built around scenic lakes and streams. Several planned retirement communities take advantage of excellent sites overlooking Belwood Lake. Large trailer parks with recreational and retirement homes have been developed near Aberfoyle and Pike Lake and in lush, isolated Spring Valley between Arthur and Mount Forest. Campgrounds, conservation areas and parks occupy other scenic locations in this vast and complex county.

This retired farmer, Ken Waters, has become an artisan.

Guelph: The Royal City

A STATUE OF GUELPH'S FOUNDER, John Galt, stands in front of the city hall. The stern visage peering across the square is that of the Scottish novelist and businessman sent to market the Canada Company's land in Upper Canada. In April 1827, Galt, a Commissioner of the company, planned and established Guelph as his administrative headquarters. He laid out its site amidst fertile land near several waterfalls on the Speed and Eramosa rivers. Galt designed Guelph's original plan and toiled diligently to secure its commercial success. He quickly constructed buildings and imported tradesmen, teachers and workers to stimulate economic development in his new community. Soon Guelph was bustling with local merchants and with pioneers. These new arrivals had come to purchase titles to properties on the Canada Company's land in the Huron tract to the west.

Guelph soon became Wellington's county seat and largest settlement. Much of Galt's original plan remains in the central area, with major streets radiating from a bend in the Speed River and terminating at "Catholic Hill," Guelph's highest drumlin. The twin spires of the Church of Our Lady overlook the business district, dominating downtown from a commanding position on this promontory. Nearby, the Speed and Eramosa rivers wind gracefully through the lush valley landscape.

Guelph possesses some of the best limestone architecture in the county, complemented by a network of wooded parks and picturesque trails along its rivers. Several traditional shady neighbourhoods close to the centre display an impressive array of dwellings, from tiny workers' cottages to dignified mansions of brick or stone. Many of Guelph's important homes overlook the downtown from its river terraces and drumlins.

Royal City Park on the Speed River.

A statue of Guelph's founder, John Galt, stands in front of the city hall.

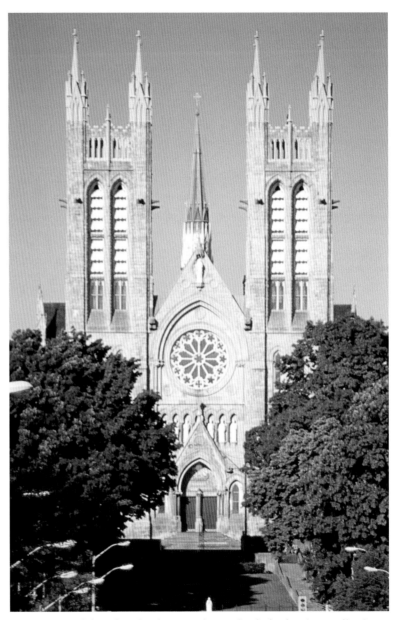

Twin spires of the Church of Our Lady overlook the business district.

A statue of "The Family" donated by the local Italian community caused a major controversy in Guelph.

The tower and facade of the Kelly-Petrie Building reflect the wealth and elegance of nineteenth-century Guelph.

A number of attractive stone churches constructed in the 1800s may be found within a few blocks of St. George's Square. Here, a statue of "The Family" donated by the local Italian community caused a major controversy. Conservative residents objected strenuously to its nudity, but common sense prevailed and the statue remains as the centrepiece of the square. A stroll along major streets from the square is rewarded by vistas of eclectic architecture in brick, stone and wood. Street names like Dublin, Cambridge, London, Fergus, Elora, Exeter, Suffolk, Norfolk, Surrey, Bristol, Liverpool, Oxford, Cork and Durham remind us of the city's British origins.

Guelph contains far too many handsome stone buildings to enumerate here. Fortunately, many have been designated as historic structures and will be preserved for posterity. The main

Wellington County Crown Attorney's Office, 25–27 Douglas Street, Guelph, built 1885.

business artery, Wyndham Street, is flanked by solid three-storey limestone blocks from the 1800s. Macdonnell Street is shared by several traditional hotels and the modern headquarters of the Co-operator's Insurance Company. On the corner of Wyndham and Macdonnell Streets, the tower and iron front of the Kelly-Petrie Building reflect the wealth and elegance of this nineteenth-century community. The former Post Office, now a county administrative building on Wyndham Street, exemplifies early Federal institutional architecture.

The River Run Centre, Guelph's new concert hall, is situated on Woolwich Street beside the Speed River. The concert hall was to be built into the ruins of an historic limestone speed skating rink on the site, but the rink burned to the ground before this could occur. Despite fierce opposition from those who could see no merit in a cultural centre, River Run Centre was opened in 1997. One facade of the speed skating rink was preserved and rebuilt in front of its main hall. Guelph now possesses one of the most acoustically perfect concert spaces in the province. It is used as a recording studio by many orchestras. The view through River Run's sweeping glass facade is breathtaking. At intermission, patrons can peer out or stand on an adjacent dock to contemplate the tree-lined bank and elegant homes across the stream. Guelph's magnificent new concert facility is now used almost every day of the year.

A plaque on the limestone railway overpass at the foot of Macdonnell Street describes the founding of Guelph and its first building, the Priory, a model of which may be seen in Riverside Park. The waterfall and rocky ruins of Allan's Mill at nearby Heritage Park commemorate Guelph's early industries. Not far to the north, the tall, slender spire of St. George's Anglican Church stretches skyward beside the water.

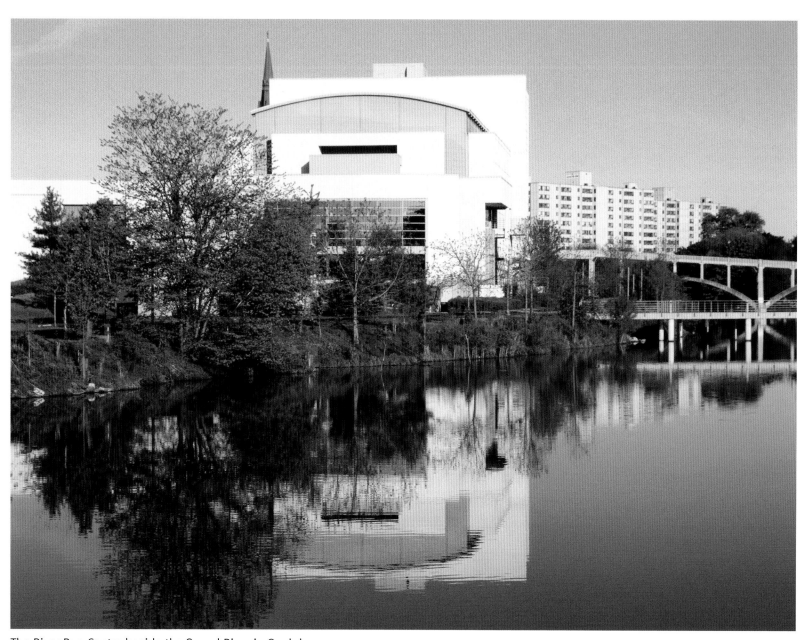

The River Run Centre beside the Speed River in Guelph.

Across the street, the Wellington County Court House is reminiscent of a medieval European castle. Douglas Street, lined by historic stone buildings between the court house and St. George's Square would be perfectly appropriate in any European city.

Every Saturday morning Guelph's downtown farmers' market offers fresh produce, poultry, baked goods, meat and crafts from its indoor and outdoor stalls. Here, regulars enjoy coffee and sweets while they chat with their friends. University students appreciate the market's friendly country atmosphere, fresh produce and bargain prices. Occasionally Suzuki music students provide classical entertainment with their violins and cellos. The Church of Our Lady, looming in the background, is reminiscent of similar views from the market squares of Europe.

Guelph is a hotbed of active cultural and sports associations. The Guelph Storm hockey team and the Guelph Royals Baseball team have enjoyed considerable success over the years. Guelph Little Theatre regularly wins awards for its excellent productions. Before its termination in 2006, the Spring Festival was world renowned for its outstanding classical performances and original operas. The Jazz Festival, the Guelph Symphony and the Kitchener-Waterloo Symphony provide musical entertainment for a wide variety of tastes.

Many renowned musicians call Guelph home. Stephen Fearing has performed across North America and is a member of Blackie and the Rodeo Kings. James Gordon is a singer, songwriter and political activist whose music and theatre productions are widely known. Many other groups offering blues, heavy metal, jazz, punk rock and folk music are based in Guelph. They can often be found playing in one of

Guelph's downtown farmers' market offers fresh produce, poultry, baked goods, meat and crafts from its indoor and outdoor stalls.

The Church of Our Lady, looming in the background, is reminiscent of similar views from the market squares of Europe.

the city's pubs or restaurants and at festivals across the country. Every year the Hillside Festival combines local and international talent on the island in Guelph Lake. In July sturdy Italian men scale greased poles and roll rounds of cheese along city streets. During the Multicultural Festival, Riverside Park throngs with painted children, happy picnickers and costumed ethnic groups. Ribfest attracts gourmet barbecuers who compete to create the most succulent marinades for their meat. On Canada Day fireworks light up the sky across the city. In December the Santa Claus parade with its bands and floats attracts children and adults alike. Downtown businesses frequently sponsor music and outdoor sales on Wyndham Street. Numerous productions of all kinds are staged at the university. Sports fields, dance studios and tennis courts abound. The Evergreen Centre beside Riverside Park provides modern meeting rooms and numerous activities to Guelph's increasing population of senior citizens. A number of excellent restaurants and golf courses now serve the city.

Guelph is easily accessible to the Greater Toronto Area and provides many local jobs. Linamar, Sleeman Breweries, The Co-operator's Group and the university offer numerous positions. The city's economic base is widely diversified among various sectors, insulating it from employment declines. Several new industrial areas are being developed to attract new business. The presence of the university has stimulated agribusiness enterprises and associated research facilities nearby. Guelph continues to combine its small town ambience with many big city advantages. Recent rapid population growth is but one reflection of these desirable characteristics.

Many groups offering blues, brass, heavy metal, jazz, punk rock and folk music are based in Guelph.

The University of Guelph

Education on the campus began over a hundred years ago when the Ontario government purchased a 200-hectare (500-acre) farm from Frederick William Stone on a drumlin south of the Speed River. In this promising location, the Ontario School of Agriculture opened its doors on May 1, 1874. In 1880 the name of the institution was changed to the Ontario Agricultural College (OAC) and Experimental Farm.

In 1903, OAC was joined on campus by the Macdonald Institute to provide instruction for women in "nature study, manual training, domestic science and domestic art." In 1922 the Ontario Veterinary College relocated from Toronto to become the third addition to the campus. It is, in fact, the oldest of the colleges and the oldest of its kind in North America, having been founded in Toronto in 1862. The colleges were affiliated with the University of Toronto.

On May 8, 1964, the *University of Guelph Act* was passed by the Ontario legislature, bringing the three colleges together into a single institution. A three-semester system was established to offer courses year-round, a major innovation at the time. In October 1964 the Senate of the University of Guelph created Wellington College to offer degree programs in arts and sciences.

At the University of Guelph's first convocation in May 1965, Dr. J. D. MacLachlan was installed as president. The former premier, George Drew, a resident of Guelph, became its first chancellor. Graduates of the new university began to receive their degrees from Guelph, rather than from the University of Toronto. Appropriately, John Kenneth Galbraith, an early graduate and harsh critic of OAC, received the first honorary degree. Upon meeting him on an early morning

MacKinnon Building — a part of the '60s expansion.

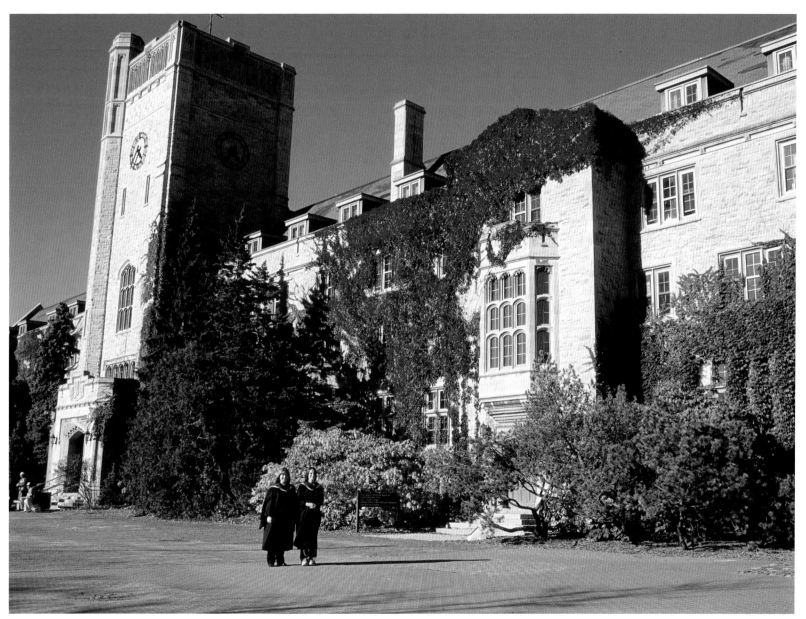

Historic Johnston Hall opened in 1932.

Creelman Hall, a favourite campus cafeteria.

walk, one of his former Guelph professors informed him that the university should have taken away his original degree rather than conferring an honorary degree at its first convocation.

In 1967, Dr. W. C. Winegard became president and the university began a period of rapid growth and development. Through its activities across a province-wide network of campuses and research facilities, the university has had a major impact upon education and research in Canada. A number of international programs, overseas commitments and links to foreign institutions have strengthened its world-wide reputation. Locally, it has research stations at Elora and Arkell, and affiliate institutions at Ridgetown, Ontario, Alfred (near Ottawa) and Humber College in Toronto. For a number of years the University of Guelph has been ranked as the top comprehensive university in Canada.

College Royal

College Royal was established in 1925. From somewhat humble beginnings, it has become a major event, with competitions, festivities and a campus open house. Agriculture and livestock shows are still important, but College Royal has grown to include dog shows, a photography contest, a chemistry magic show and demonstrations on human health and fitness. The open house provides an opportunity to see what happens in the university's leading-edge research laboratories, to observe veterinary medicine in practice, to tour a sculpture studio or to watch a theatrical performance. "If there are livestock in the hockey arena and they're not wearing skates, it's College Royal. If there are students sawing logs, throwing pies, baking cookies and square dancing, it's College Royal." The annual College Royal dance has become one of the social highlights of the year.

College Royal is the largest student-run open house in Canada, attracting more than 30,000 visitors during a weekend. This celebration successfully combines Guelph's agricultural past with its contemporary character as a learner-centred institution with a major research emphasis. Since the beginning, the city and the university have benefited from their historic association. This symbiotic relationship continues as both grow, develop and confront the challenges of the future.

Macdonald Hall, originally Macdonald Institute, established in 1903.

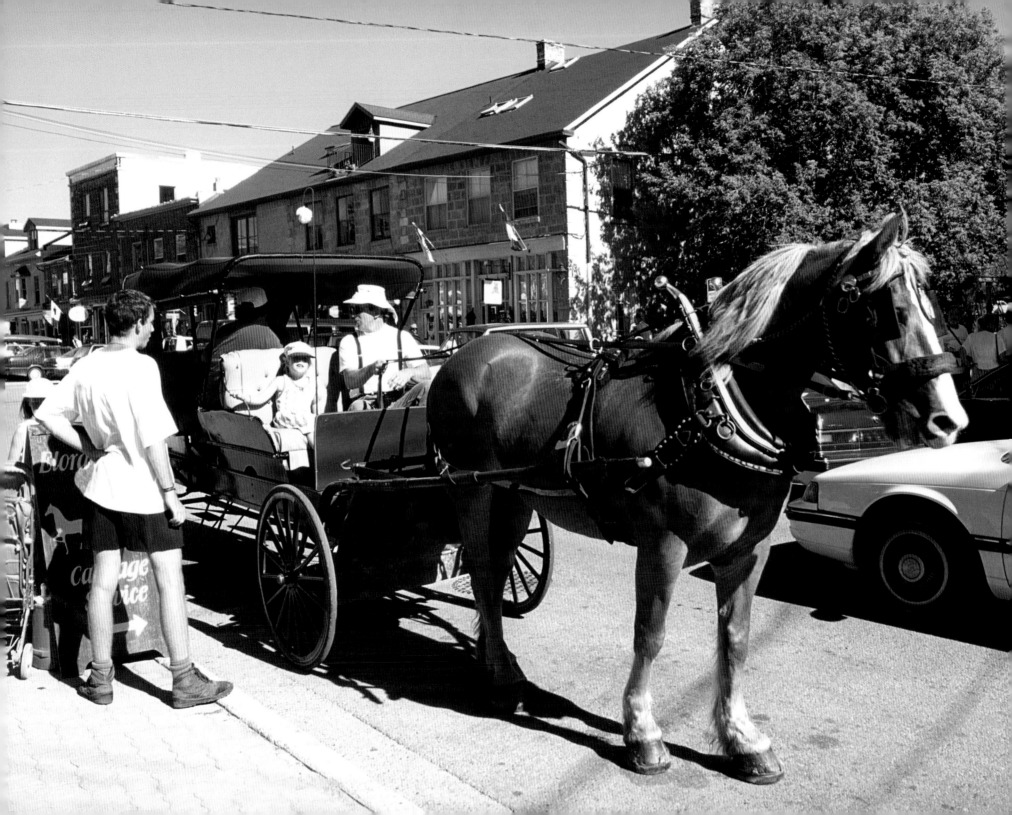

Elora and Fergus: Friendly Rivals

ELORA AND FERGUS ARE FORMER mill towns with much in common. Both were established at falls on the Grand River in the early 1830s and both became service centres for their rich agricultural hinterlands. They are only 4 kilometres (2½ mi.) apart in remarkably similar geological environments. Their growth and development were parallel until the turn of the century when they diverged dramatically.

After 1900 they began to differentiate. Given their proximity, improving roads and motorized transportation, competition became fierce. As the diligence of "industrious Scottish settlers" in Fergus led to a greater variety of industry there, Elora began to suffer from competition generated by its rival. Today Elora's economy depends heavily on tourism, while that of Fergus reflects its industrial roots. The population of Fergus has continued to increase more rapidly than that of Elora. Their rivalry continues, even as both have become part of Central Wellington Municipality.

By the time permanent European settlers arrived in Wellington County, few indigenous groups remained. In 1648 the Iroquois, armed with matchlock rifles obtained from the Dutch at Fort Orange (Albany), invaded the territory of the Hurons in Ontario. With their superior weapons, the Iroquois dispersed and practically annihilated the Hurons whose flint spear points and arrows were no match for the guns used by the invaders. Then the Iroquois attacked the Attiwandaronk (Neutrals) and defeated them in 1651 at the great battle near the present site of Hamilton.

When the Iroquois swept across southern Ontario, members of the defeated Attiwandaronk Nation took shelter in the rugged 6-kilometre (3¾ mi.) Elora Gorge at the confluence of the Grand River and Irvine Creek. For years this gorge and its caves had been sacred to the native peoples, so when the retreating Attiwandaronk abandoned their villages, they hid their precious wampum beads in a cave downstream from the site of Elora. After a heavy rain in 1880, two local

Elora is one of Ontario's finest examples of a well-preserved mill town from the 1800s.

boys discovered several of the beads that had washed out of the cave. They are now on display in the Royal Ontario Museum in Toronto.

The Iroquois subsequently swept across southern Ontario unchallenged, destroying villages as they went. In 1696 the Sulpician missionary Galinée described the region as nothing more than a "stalking ground for deer and bear," and for the next hundred years there are no detailed accounts of the area. French maps at the time labelled the western peninsula of the province as *nations détruit*, or tribes exterminated. Wellington County lay open to the settlers who came to colonize the wilderness.

The Founding of Fergus

Fergus was established by the Honourable Adam Ferguson, a Scottish lawyer sent to Canada by the Highland Society of Scotland to investigate colonization possibilities. He returned to Scotland and persuaded fellow lawyer James Webster to emigrate to Canada with him.

They arrived at the banks of the Grand River in 1833 accompanied by six of Ferguson's seven sons. Armed with a deed and title to 2,954 hectares (7,300 acres), they set out to build a settlement for "carefully selected Scottish immigrants who possessed money and education." Fergus was to be a "centre of growth and activity" in Upper Canada. In 1834 Ferguson constructed a primitive bridge across the Grand River. Within a year Fergus had a tavern, four streets and 70 inhabitants.

Ferguson soon departed, but two of his sons and Webster continued to promote the community to enterprising Scottish immigrants.

Early Industry

Originally known as Little Falls, Fergus was renamed to honour Adam Ferguson, co-founder of the community. The first mill was established where the Grand River cascades over a falls just off St. Andrew Street. The "enterprising Scottish settlers" continued to build Fergus into a prosperous community, and when the population reached 1,000 in 1858, the settlement was incorporated as a village.

Fergus possessed several sawmills, distilleries, breweries, flax and woollen mills, tanneries, foundries and a stave factory. The Templin Carriage and Wagon Works began in 1869, and a sewing machine factory became one of its principal industries by the 1870s. The history of Fergus in the early 1900s was one of attracting a wide variety of manufacturing and processing plants to provide local employment. Much of its success as an industrial community and service centre resulted from vigorous local promotion and the acquisition of a Provincial Highway in the 1920s.

The Gorge at Fergus

Just off St. Andrew Street, the Grand River cascades into a whirlpool called Mirror Basin at the bottom of the gorge. The river is crossed by the Milligan pedestrian bridge running from the former Beatty brothers foundry to Templin Gardens. Beatty's lovely limestone building beside the falls was once used to fabricate farm implements and then appliances. For a number of years it was the site of the Fergus market, but is now being converted into retail shops. From the Milligan bridge there are excellent views of Melville United Church, the rapids and Mirror Pool.

In the 1800s complaints about "nasty pigs" that had the run of town, led to the construction of a "pig bridge" not far from today's Milligan bridge. This pig bridge linked new pigpens to pastures south of the river. Much to the relief of local women, the roaming pigs were induced to cross their private bridge and abandon the streets. Despite its narrow, slippery surface, the pig bridge soon became a popular shortcut for pedestrians crossing the river. Ultimately, it was replaced by a pedestrian span, the Milligan bridge.

Today a walk from the bridge along the river is rewarded by spectacular views of the gorge and the luxuriant flower display in Templin Gardens.

Templin Gardens stand beside the Grand River in Fergus.

The Highland Games

Once a year, on the second full weekend of August, Scotland comes to Canada as Fergus celebrates its Scottish heritage by hosting the Highland Games. The games began as a one-day event with 300 participants in 1946, but now attract competitors from around the world. Each year over 30,000 people attend the games, which feature an evening band tattoo and many exciting Scottish competitions. These include highland dancing, piping contests, the hammer throw and the caber toss,

Scotch tasting has become an extremely popular event for those less athletically inclined. During this gala festival, the

Fergus celebrates its Scottish heritage hosting the Highland Games.

sights and sounds are intoxicating as well. Pipe bands skirl while husky Scots in multicoloured kilts propel heavy balls or logs into the air. Nearby, youthful dancers bound gracefully between recumbent swords. Rows of colourful tents accommodate everything from duelling warriors to food and souvenirs. The games combine many aspects of Scottish culture with a traditional fall fair. For several days a year, Fergus returns to its Scottish roots with a vengeance. Streets are festooned with Scottish flags while banners and kilts appear everywhere.

Fergus Today

Today Fergus is a thriving service centre with diversified industry, modern residential suburbs and rich history. The town offers excellent accommodations in the Breadalbane Inn and several bed-and-breakfast establishments. The citizens are friendly and the ambience is pleasant. Despite its strong industrial legacy, the atmosphere remains that of a bustling market town on the river. Its economic prospects and tourist potential are great, as is its future as a growing residential community. On the edges of town, sprawling new suburbs, plazas and industries contribute to its rapidly increasing population and booming economy.

The Founding of Elora

Elora's site had been visited as early as 1817 by travellers who described the scenic beauty of the cataract and craggy chasm. They also recognized its potential for power. In 1817 Roswell Matthews, a Welshman from the United States, attempted to

The former livery stable in Fergus now accommodates modern shops.

construct a dam, which washed away every spring. Unable to grind wheat locally, he and his sons hollowed out a log and floated it with 16 sacks of wheat downstream to Galt where they sold the wheat for 50¢ a bushel and the dugout canoe for $2.50. This incident ended early attempts to settle Elora.

In 1832 Captain William Gilkinson of Irvine, Scotland purchased the 5,666-hectare (14,000-acre) tract by the river where he established Elora, for seven shillings and sixpence per acre. Gilkinson's ambition and ample funds provided Elora with excellent leadership and generous amounts of capital until his untimely death a year later. Elora declined for a few years but grew again after 1844 when Charles Allan

The Elora mil has become a tourist attraction for many who come to dine beside the river.

arrived. He formed a company that purchased land where he built a grist mill and several stores. Before the mill was built, it was common for settlers to walk from Dundas, Hamilton or Galt carrying a sack of flour and provisions. From1844 until the turn of the century, Allan's efforts enabled Elora to compete successfully with its arch-rival Fergus.

The Mill Street Revival

For a number of years, Elora languished while Fergus thrived. Blessed by its magnificent site on a waterfall and a rocky gorge, Elora has always been a tourist attraction. Nevertheless, it took entrepreneurial effort and vision to transform a sleepy mill town into a major tourist destination. After lagging behind Fergus, Elora began to prosper when entrepreneurs realized the potential of the mill and the derelict industrial buildings along Mill Street.

The restoration of the Elora mill was a turning point for the village. Until 1972 it was a fully functioning water-powered mill, one of the largest in the province. After several changes of ownership, the crumbling five-storey structure was lovingly rebuilt from top to bottom. Its exterior walls, poised above the plunging falls, overlook a rocky pillar called the Tooth of Time. The mill's ramparts, which are 1.5 metres (5 ft.) thick, constituted a solid foundation for restoration and provided wide window ledges throughout the building. In the bar, a penstock supplying a small electric generator extends along an exposed rocky outcrop. Original beams have been revealed to add rustic charm to halls and bedrooms. During the winter enormous fireplaces in the public rooms provide warmth and cheer.

The Elora Mill has become a luxurious, modern hotel whose restoration was not accomplished easily. Financial hardship and opposition plagued what ultimately became the cornerstone of the "Mill Street Revival." Both the Ontario Heritage Foundation and the publication *Canada Country Inns* have acknowledged the excellence of the building's restoration. It remains the economic anchor of Mill Street as well as an important local attraction.

In 1978 a Guelph company purchased land that formerly housed factories on the north side of the street just east of the mill. The remains of limestone walls were incorporated into a courtyard that now accommodates a variety of clothing, craft and candy shops. In the beginning many businesses changed hands and others went bankrupt. The negative and sometimes hostile attitudes of locals towards newcomers didn't help. Conflict between new and old residents delayed the improvement of sidewalks and parking along the street.

Slowly at first, and then with increasing momentum, initial risks paid off. Tourists came to purchase antiques, to view the scenery and to dine beside the river. Soon artists and artisans joined the merchants, making and selling their wares in and around the original Mill Street nucleus. Elora is home to numerous potters, glass-blowers, painters and sculptors. Several of the delightful shops on Mill and Metcalfe Streets sell locally created art, furniture, custom gold and silver jewellery, knitted woollen products, brass rubbings and antiques. The authenticity of this merchandise contrasts starkly with products from China found in many larger tourist communities.

From its Mill Street genesis, the original tourist nucleus has crept up the hill along Metcalfe Street to the intersection

Financial hardship and opposition plagued what ultimately became the "Mill Street Revival" in Elora.

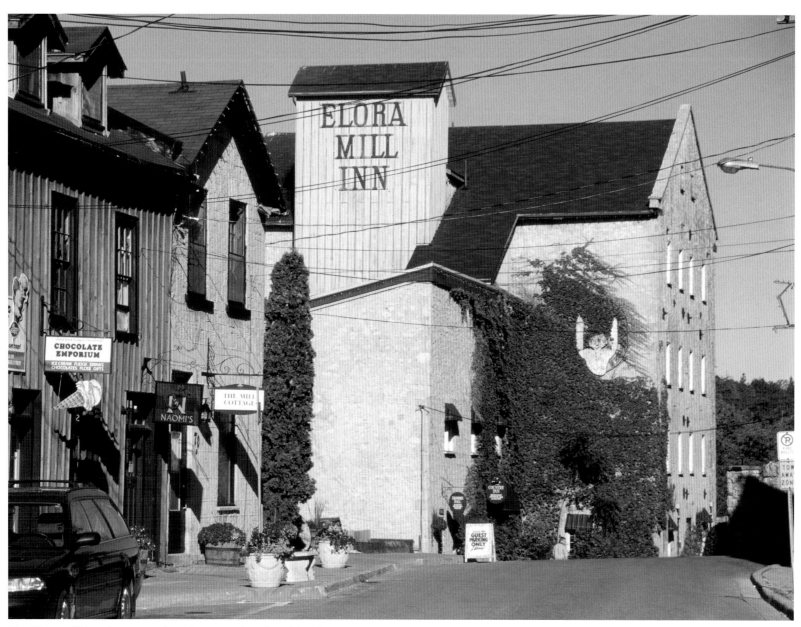

The Elora mill has become a luxurious, modern hotel but its restoration was not accomplished easily.

of Geddes Street. The former Dalby House at this intersection has become the Iroquois Hotel. Its triangular facade imbues this corner with memories of 1865 when it was constructed. A number of excellent bars and restaurants have been established throughout the town. The Elora General Store combines country charm with a vast array of books, delicacies and souvenirs. From a shaky beginning, Elora has capitalized successfully upon the tourist trade. From June to October, buses from Toronto and Kitchener crowd the village with shoppers and visitors. Most shops are open year-round to serve an increasing influx of winter visitors.

The former Dalby House, built in Elora in 1865, has become the Iroquois Hotel.

The Festival

Elora's Three Centuries Festival was established in 1979 to showcase local artists and to utilize several acoustically excellent churches. Renamed the Elora Festival, it has become one of Canada's premier musical events, drawing crowds from across North America to a wide variety of classical, pop, folk and dramatic performances by Canadian and international artists. For three weeks each summer, Elora is filled with festival patrons and its shops are busier than usual. Late evening outdoor performances feature county music, jazz and blues. Recently, the festival has experienced many sold-out concerts. Much of its success is the result of tireless efforts by

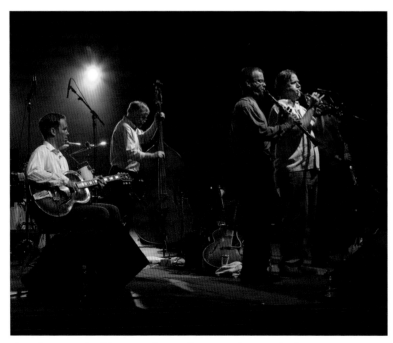

The Elora Festival is one of Canada's premier musical events.

Noel Edison, its founder. He is the conductor of the Elora Festival Singers and the Toronto Mendelssohn Choir.

The Township "Gambrel Barn" on the edge of town is normally used as a storage facility. During Festival Season, it becomes a unique and "acoustically perfect" concert hall. Birds add their voices as they swirl and flit across the ceiling, seemingly keeping time and tune with the orchestra and chorus. Occasionally, a stray raccoon ambles across a beam. When its doors are open, pungent aromas of wood smoke from nearby campsites waft through the air. Galas at the Barn are inevitably sold out.

St. Mary's Roman Catholic Church, Knox Presbyterian Church and St. John's Anglican Church host concerts that are not large enough to require the Gambrel Barn. Tea with the Vicar under the tent beside St. John's has become a regular part of the festival experience.

Hollywood has also discovered Elora's attractions. When *An American Christmas Carol* starring Henry Winkler was filmed in the village, Mill Street was converted into an English country town and locals grew beards to perform as extras. An abandoned mill, which became Scrooge's workshop, was burned for the production. More recently, a number of other major film and television features have been filmed in the village and around the quarry.

Elora Today

Elora's side streets abound with historic architecture. In much of the town, careful attention has been paid to the restoration of significant homes. The Drew House with its wide surrounding porch on Mill Street east was the residence of

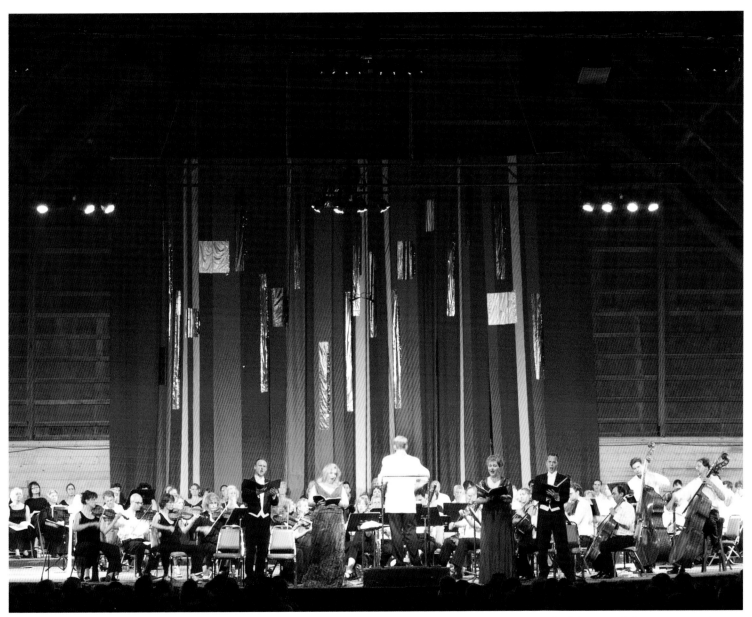

The Township "Gambrel Barn" on the edge of Elora is normally used as a storage facility. During Festival Season, it becomes a unique and "acoustically perfect" concert hall.

George Drew, Premier of Ontario. It is now a bed-and-breakfast establishment. Rosemount Cottage, a stately limestone mansion on Geddes Street near St. Mary's Church, was the original home of St. John's School, an exclusive private academy. The liquor store just south of the river occupies a carefully renovated drill hall built in 1865.

The Drew House, now a bed and breakfast in Elora.

Although Elora's churches are not as grand as those in Fergus, they remain important to the community. It is reported that the Rev. John Smithhurst, an early pastor of St. John's Church, was the lover and first cousin of Florence Nightingale. Precluded from marriage by being related, Florence Nightingale went to Crimea to tend to the wounded while the reverend became a pastor in Elora. The silver communion set in the church is reputed to be a gift from Florence Nightingale.

The 47-kilometre (29-mi.) Elora–Cataract trailway along the former Credit Valley Railway attracts numerous hikers and cyclists. They can travel on this part of the Trans-Canada Trail through Elora and Fergus from the Shand Dam at Belwood to the Forks of the Credit. With its gorge, festival, parks and trails, Elora has become a year-round attraction.

Elora is not all music and romance, scenic beauty and pleasurable visits. It is also a place of work and residence, a rural service centre, a commuter dormitory and a generator of wealth and enterprise. Its small-town atmosphere, riverside sites and parks have attracted families from Kitchener, Waterloo, Guelph and even Toronto. In the past, lower house prices were also an attraction, but the gap has narrowed since more and more commuters have discovered Elora. Today Elora is one of Ontario's finest examples of a well-preserved mill and tourist town from the 1800s.

Elora and Fergus remain rivals, but both are now part of the municipality of Centre Wellington. They will continue to be successful if they carefully regulate their growth and development.

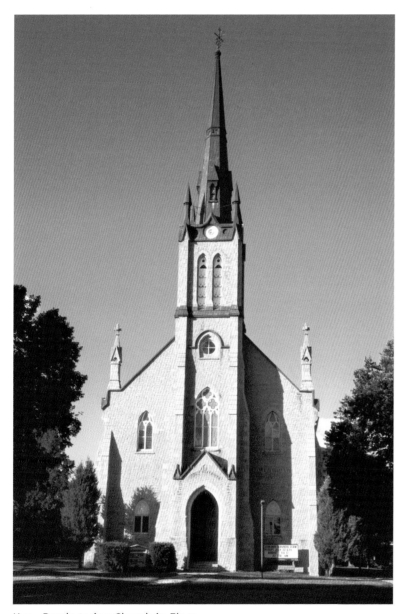

Knox Presbyterian Church in Elora.

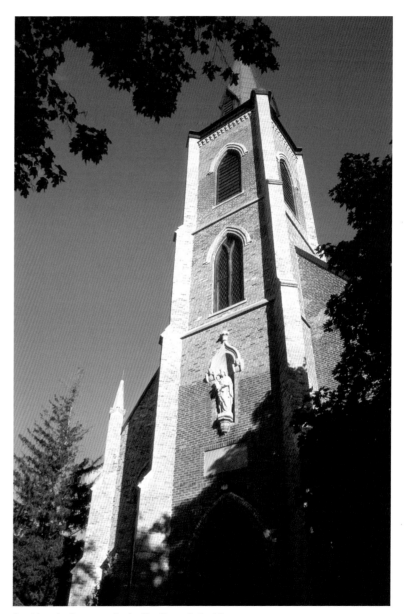

St. Mary's Roman Catholic Church in Elora.

Mill Towns, Historic Villages and Ghost Towns

WELLINGTON COUNTY'S PIONEERS ALMOST always established their first settlements on streams providing water power to run a mill. Farmers required the mills to grind grain into flour and to saw logs into lumber. As the population increased, entrepreneurs established general stores and taverns to serve customers attracted by the mills. Since good dam sites were usually convenient bridging locations, new roads were promptly built among them.

Mill Towns

Initially, mill towns grew quickly because they enjoyed transportation advantages over communities without a stream. Mill towns and villages soon began to serve the surrounding area that was within a day's return journey by horse and buggy. Populations increased, and early mills were joined by additional manufacturers. Before rural mail delivery began in 1911, the general store, which housed the post office, attracted everyone requiring postal services. Hotels were built to accommodate guests and provide sustenance to visitors and salespeople. At the weekend, markets thronged with farmers who then adjourned to the pub for conversation and merriment. Mill towns rapidly became social and economic centres for large rural hinterlands. Many have fascinating histories and significant architecture.

The former Aberfoyle schoolhouse.

Historic Villages and Hamlets

For some, historic villages and hamlets are even more fascinating than thriving former mill towns. Visiting them provides intimate glimpses of the county's early history and architecture. Some offer nothing more than crumbling foundations overgrown with weeds or lilacs where an outhouse once stood, while others reveal significant architectural treasures.

Most small settlements were established to become rural service centres. Their sites were determined by two major factors. Road conditions were abominable away from the major routes, so most transportation was by foot or horse and wagon. Travel was slow, making the most convenient location for a service centre approximately a day's return journey from the edges of its trade area. These communities were almost always at the intersection of a concession road and a side road, and were spaced relatively evenly because of the regularity of the survey system. As a result, an almost rectangular pattern of settlements developed. Many have a fascinating history of early prosperity followed by rapid decline, especially after motor vehicles replaced the horse and buggy.

A count of places in Wellington County offering goods and services provides an overview of the rise and fall of its historic villages and hamlets. *The Wellington County Directory 1871* listed 73 settlements having businesses. In subsequent years, there were small variations followed by a decline to 36 in the 1970s. Today the official County Map of Wellington shows far fewer settlements than at any time in the past. Why the decline? What happened to create ghost towns and to deplete historic villages?

Three major factors explain the demise of small crossroad communities. As long as the general store was also a post office, farmers came each week to collect their mail, visit with friends and do some shopping. For many places, this ended in 1911 when rural mail delivery began. Then farmers could receive their mail at the end of their lanes and shop from home for the wonders in the Eaton's catalogue. The necessity to visit the local settlement had all but ceased, and as business declined, hamlets lost their stores and hotels. A few years later prohibition began, closing taverns and ending (legal) drinking in hotels. Soon, many hotels went out of business, further reducing the incentive for farmers to come to town.

The final and often fatal setback came after 1931 when motor vehicles became common and roads were being paved. Then farmers could jump into a vehicle, bypass their local village and travel to a larger town offering a much greater variety of goods and services. Many settlements that survived rural mail delivery and prohibition lost their last business after 1930. Some remained as purely residential communities but others were abandoned and disappeared. The car was the nail in the coffin for what became Wellington's ghost towns, today represented only by names on old maps. Over the years, some communities have gained and lost businesses while others have acquired increasing populations of commuters or retirees.

Ghost Towns

Across the county, little remains of places such as Living Springs, Riverbank, Wagram, Cotswold, Drew, Derrynane, Parker, Metz and Petherton, all of which had a store or hotel during the 1880s and 1890s. In most, only a clump of bushes, a crumbling foundation or a house remains. After the 1930s, the increasing use of cars and trucks ensured that they were bypassed for larger communities with more attractions.

Anyone with a topographic map from the 1950s or earlier will discover crossroads communities existing only as names on a map. These include places such as Coningsby, Little Lake, Winfield, Conn, Melgund, Minto, Stirton and Goldstone. All were once important to nearby farmers, all have fascinating histories, and all were annihilated by changing technology. A few remain as quiet residential dormitories, but many have disappeared without a trace. They are a wonderful reminder of simpler days when farmers relied on them for services.

FORMER MILL TOWNS

Arthur, Clothing Capital

Arthur's downtown is dominated by Sussman's clothing stores, which have expanded to occupy a large proportion of George Street. As the largest independent clothier in Ontario, Sussman's attracts customers from as far as Toronto and London. The community's role as a regional service centre remains important, but has diminished as competition from Fergus and Mount Forest has increased. Arthur's United Church is built of limestone and has a Norman tower. It was constructed by the Methodists in 1892.

Clifford, Mill Town

Clifford's grist mill was built by public subscription in 1867. July 1, the day of Confederation, was celebrated by a building bee when its rafters were erected by local workers. This historic mill was powered first by water, then by steam, then by diesel and finally by electricity. Its old frame exterior is covered by steel siding, and rather than producing flour, it chops and mixes grains for feed. An attractive brick general store graces Clifford's main street.

Drayton, Theatre Centre

Drayton flourished as long as rail and horse were the major modes of transportation. Today Drayton's major claim to fame is the Drayton Festival Theatre. Its beautifully restored, yellow-brick town hall has become the playhouse, as well as the entertainment administrative centre for five small-town theatres.

Arthur's downtown is dominated by Sussman's clothing stores.

What was once a modest country theatre operation has become big business attracting patrons from many parts of Ontario.

On sunny summer afternoons, busloads of seniors arrive in Drayton to see shows such as *Oklahoma* or *Lost in Yonkers*. Some enjoy a delicious smorgasbord in a nearby restaurant while others snack on barbecued sausages at the historic local butcher shop. The theatre has breathed new life into Drayton as its patrons provide increasing business to its shops, B & Bs and restaurants.

Erin, Thriving Community

To reach Erin from Guelph, one crosses rolling till plains and drumlins sculpted so long ago by the Pleistocene glaciers. Now the drumlins stand, row upon parallel row, marching across the landscape like a line of cigars, all carefully oriented northwest to southeast.

Mundell's Lumber Company remains the only working water-powered planing mill in Ontario, still manufacturing sashes and custom woodwork. Its worn wooden exterior is

An attractive brick general store graces Clifford's main street.

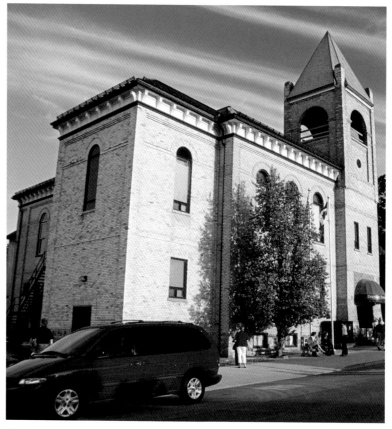

Today Drayton's major claim to fame is the Drayton Festival Theatre.

Mundell's Lumber Company in Erin remains the only working water-powered planing mill in Ontario.

unimpressive, but inside, the whirr of water-driven pulleys and whine of slashing saws take us to an earlier era. Pungent aromas of sawdust and freshly planed planks fill the air and the nostrils.

The Rob Roy Inn seems less spontaneous and more commercial than its early predecessors. Rather than a rowdy tavern, the hotel has become a haven for those craving beer and pub food. Recently its name has reverted to the historic Busholme Inn.

Erin's Stanley Park is a secluded oasis that has been a recreational area and choice site for summer cottages for years. Tall, dark stands of pine protect it from noise and traffic. The lake is surrounded by picnic areas, now being challenged for space by new cottage and trailer developments.

Boston Mills Press has been a fixture on Main Street for many years. Today a number of boutiques and specialty shops

The Rob Roy (now Busholme) Inn.

Erin's Stanley Park is a secluded oasis that has been a recreational area and choice site for summer cottages for years.

Main Street Erin is home to many fine shops and two publishers.

Eileen and her calf. The Erin Fall Fair was established in 1850 and continues to be a major attraction every October.

contribute to the street's attractive character, complementing Steen's Dairy and Holtom's bakery, two of Erin's oldest businesses.

The Erin Fall Fair was established in 1850 and continues to be a major attraction every October. Its horse-shoeing and sheep-shearing demonstrations reflect its rural roots, just as the truck pull and machinery displays represent a more recent era. The fair attracts children and teenagers to the midway with its ferris wheel, merry-go-round, and bumper cars while adults watch from the sidelines. Contemporary musical groups, and baking competitions attract large crowds every year.

Harriston, A Solid Settlement

According to the *Wellington County Directory 1872–73*, Harriston "has a bright prospect before it, situated as it is in the centre of a rich and fertile agricultural district. Its public and private

The Coronation Hotel was built in Harriston in 1882.

Harriston United Church.

buildings will compare favourably with those of older towns, and during the present season, a splendid three-storey brick building with mansard roof, has been erected by Alexander Meiklejohn, Esq.… The entire building is an ornament to the village."

The Coronation Hotel built in 1882, the Town Hall built in 1916, and the magnificent three-storey Meiklejohn Block remind us of Harriston's glory days as an important community serving a large rural hinterland.

The former CPR railway station has become a seniors' centre. Large brick houses on shady, tree-lined streets and the tranquil country ambience offer much for those leaving a farm or desiring to escape the city. During the last several years, plaques have been affixed to buildings with historical designations. Beautiful gardens and excellent landscaping seem to be a local hallmark. Everywhere, Harriston's friendly people welcome visitors and initiate delightful conversations.

Hillsburgh, Trout and Tranquillity

For early travellers, Hillsburgh provided a delightful stopping place and a final destination for settlers who could not acquire land near Erin. A hundred years ago, trout flourished in the

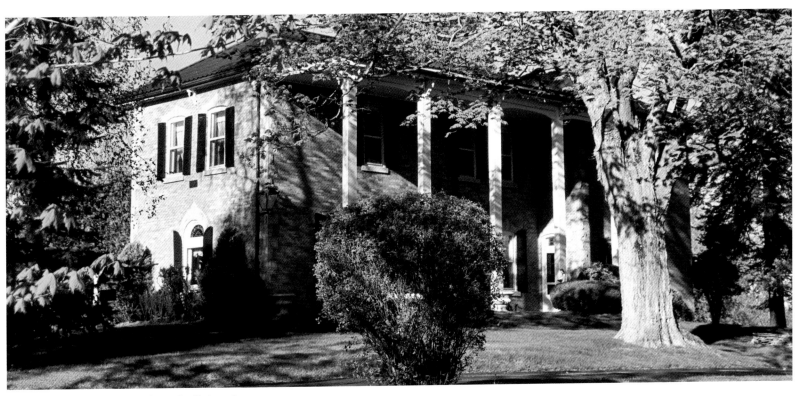

A gracious home on the edge of Hillsburgh.

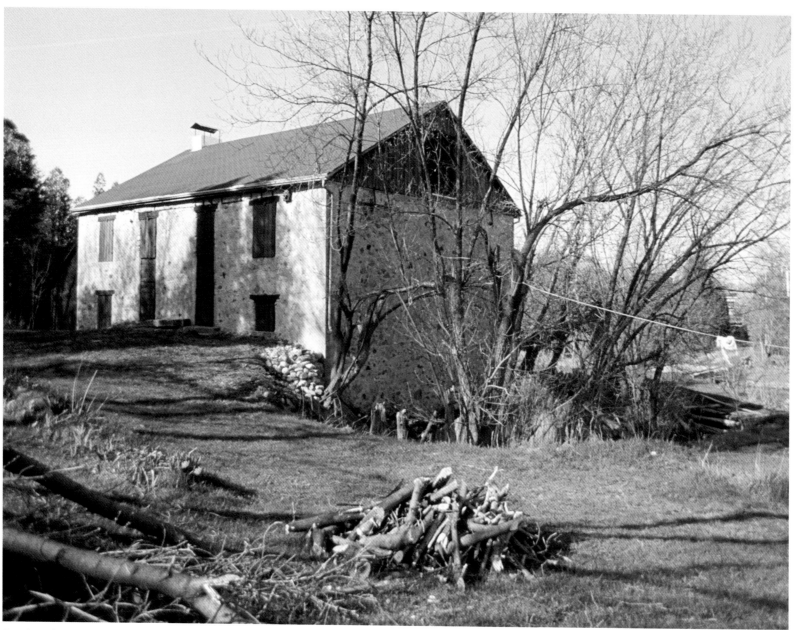

An abandoned mill on the edge of Hillsburgh.

Credit River and in the millponds. Early on, a private fishing club was established and water was set aside for the exclusive use of members. For a number of years, the Exchange Hotel and three others provided excellent cuisine, comfortable rooms and good stabling out back for those who had come by stage or horse.

The third store built by the first settler, William How, at 18 Main Street is now a beauty salon.

The Gooderhams who founded the Gooderham and Worts Distillery first established their grist mill and cooper shop in Hillsburgh in 1846. Their original house still stands at 52 Main Street.

Mount Forest, Northern Capital

Mount Forest is Wellington's thriving northern service and industrial centre. Its massive grain elevators serve farmers from the surrounding area, and its magnificent mansions reflect early prosperity. Increasing numbers of Mennonite farmers who have moved to the area, shop or sell their produce, adding character and commerce to the town.

A statement in the 1906 *Historical Atlas of Wellington County* summarizes reasons to visit Mount Forest: "The hotel accommodations are ample and first-class. The business

A specialty bakery in Mount Forest.

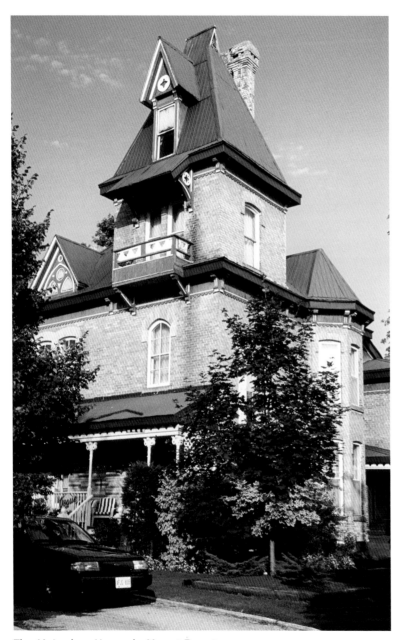

The McLachan House in Mount Forest.

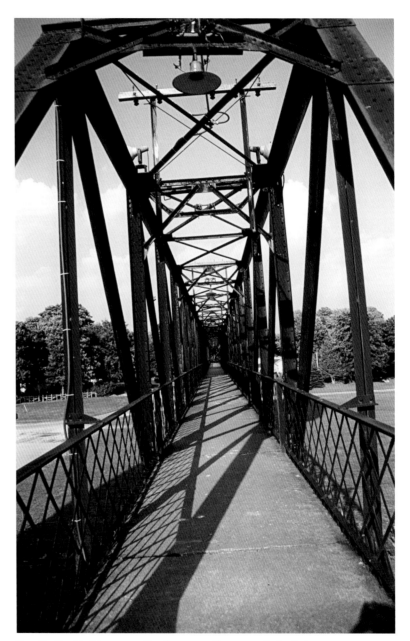

Trestle foot bridge over the former railway yards in Palmerston.

blocks, churches and other public buildings are handsomely built, modern and up-to-date in every respect, and the continuation of Mount Forest's growth in population and wealth is undoubtedly assured."

Palmerston, Railway Town

Some communities owed their early prosperity to the acquisition of a railway connection, but almost all of Palmerston's economy was tied to its function as a railway junction and repair depot. The railway yards occupied a large area in the centre of town, almost dominating the community. By 1983 the tracks had been removed after freight traffic ceased.

Little remains of the railway except a well-preserved station, a water tower, a pedestrian trestle bridge over the former railway yards, and short tracks leading nowhere. The once-grand town hall, which was built in 1877 for $2,000, is now in need of a paint job and other repairs. A few elegant houses may be found, but the general impression is of a community that has declined.

Little remains of the railway in Palmerston.

A few elegant houses may be found in Palmerston, but the general impression is of a community that has declined.

Rockwood, Limestone Oasis

Rockwood developed in a spectacular glacial valley flanked by limestone cliffs and riddled with caves and potholes. In 1844 John Harris and his wife established the Society of Friends (Quakers) and built a meeting house, which remains as a Presbyterian church.

Rockwood had many industries in addition to the lime kilns along the river. The Harris Woollen Mill, established in 1867, became widely known as a producer of high quality woollens, tweeds, blankets and flannels. Nearby, Harris built sturdy stone cottages for his workers. Before it closed for good in 1930, the mill was powered by water, steam and electricity.

In 1844 John Harris and his wife established the Society of Friends (Quakers) and built a meeting house, which remains as a Presbyterian church.

In 1855 William Wetherald founded the Rockwood Academy, a boarding school for boys.

Much of its wool was imported from Australia because the local product was too coarse. Today the Harris Mill is the centrepiece of the Rockwood Conservation Authority Park.

In 1855 William Wetherald founded the Rockwood Academy, a boarding school for boys. Its stone building is now used as a sculpture studio and has been the location of several Hollywood movies. Recently, the Conservation Authority Lake has also been the site of Hollywood movie filming.

Picturesque settings for homes surround the limestone gorges and some tourist-oriented businesses have opened on

A French restaurant has occupied this historic house in Rockwood for years.

the main streets. A French restaurant has occupied a historic home there for many years. Paul Morin's studio on Main Street displays his magnificent art.

HISTORIC VILLAGES AND HAMLETS

Salem, Faded Glory

Salem prospered mightily for a few years in the 1830s, until Sam Wissler, its chief promoter and businessman, died and his estate was frozen. An additional blow occurred when the railway bypassed Salem for Elora, leaving Salem on a back road leading nowhere.

Today the limestone ruins of once-thriving mills along the creek cling precipitously to cliffs near the bridge. Here the river gushes madly through a narrow obstruction into the bowels of the limestone depths. It plunges into the gorge, unleashing the power that provided incentives for major business ventures in the 1800s. But all is not in ruin; just downstream, several former factories have been renovated into apartments. Nearby, artisans create in restored factory buildings. Salem has never become as commercially successful as Elora, but it provides some delightful residential settings.

Aboyne, Faded Dreams

Between Elora and Fergus, the site of Aboyne was surveyed and promoted in the 1870s to compete with its nearby rivals. Along this 6.4-kilometre (4-mi.) stretch of the Grand River, Aboyne, Kinnettles, Elora and Fergus were to exploit the

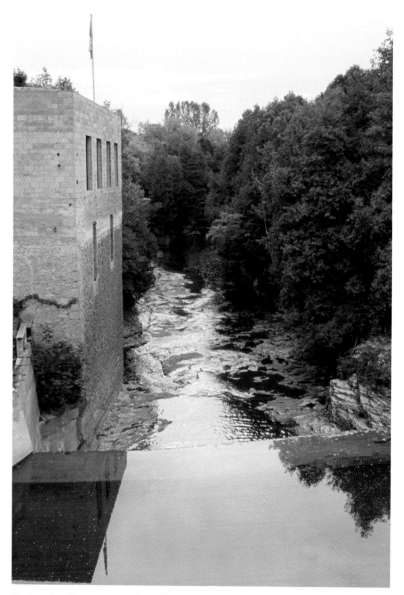

Today the limestone ruins of once-thriving mills along the creek cling precipitously to cliffs near the bridge in Salem.

The former Aboyne grist mill.

excellent water power. In its heyday, Aboyne boasted a tannery, hotel, and three mills employing a dozen workers. The survey showed 120 lots, many of which were snapped up by speculators. Unfortunately, Aboyne could not compete with Elora and Fergus, and little remains except some ruins and a splendid stone home built into the remains of the grist mill. All vestiges of Kinnettles have long since been obliterated by sprawling subdivisions that spread between the towns.

Aberfoyle, Mill and Market

Aberfoyle was once an important service centre and mill town. Its history is preserved in the tall, perfectly preserved stone mill with its attractive dam, pond and restaurant. The former blacksmith shop has become an outlet for skidoos and ATVs, while the flea market draws enormous crowds on the weekend. The schoolhouse is now an antique shop.

Aberfoyle's flea market draws enormous crowds on the weekend.

Just to the north of the hamlet, two pleasant residential enclaves have been developed around spring-fed lakes and the Aberfoyle Creek. Mill Creek Country Club and Mini Lakes Country Club offer residential sites by picturesque streams. Carefully landscaped residential areas surround waterways that are well stocked with fish for the tenants. Amenities include a clubhouse, swimming pool, canoeing, fishing, horseshoes and many social activities. Panoramas of boats and docks around the water are reminiscent of those in Muskoka or the Kawartha lakes.

The House of the Shepherd is an original log cabin used for guests of the Presbyterian Crieff Hills Community.

The former Maclean home has become a Danish restaurant called Sunset Villa and the administrative centre for Mindepark in Crieff.

Crieff, Secluded Retreat

Crieff is near the southern edge of the county in the midst of woods and rolling, stony moraine. Here 80-hectare (200-acre) lots were surveyed, purchased for farming and then abandoned by settlers who had equated dense forest with fertile soil. Sadly for them, once the trees had been cut, the soil was coarse and rocky, mostly good only for pasture. Settlers could provide but few surplus crops to sell in a service centre. Nearby farmers required some services, so by 1871 Crieff supported several blacksmiths, a general store with a post office, and a hotel.

Crieff did attract a few settlers who built several splendid limestone homes in the Ontario Gothic style. More recently, their steep roofs, sturdy construction and symmetrical facades have made them attractive to commuters and nonfarm residents. Knox Presbyterian Church was constructed for the local congregation in 1882. Its grounds and gates were improved in 1924 with the financial assistance of John Bayne Maclean, a local resident who founded the Maclean-Hunter publishing company. The former Maclean home has become a Danish restaurant called Sunset Villa and the administrative centre for Mindepark with its residential sites, kettle lakes and ornate cemetery. This property makes excellent use of the rugged local moraine and heavily forested environs.

The Presbyterian Church developed a heavily forested area near a small kettle lake at Crieff's western edge as a retreat and educational centre. When Maclean died, he bequeathed about $600,000 and 200 hectares (500 acres) to the church, which created this delightful oasis among the reforested hills. Several of its historic log homes have been renovated into sleeping cabins, and a spacious meeting facility has been added.

Morriston, Bisected Village

Brock Road bisects the village with an almost steady stream of traffic. Morriston's main street has restaurants, antique shops, a gas station and a few houses. Unfortunately, it has been ruined as a residential environment by the heavy traffic. A few historic stone buildings remain along the highway and several delightful houses stand a block or two away. Residents hope that a diversion of Highway 6 will once again enable this split community to become one.

A restaurant in a historic building on Morriston's main street.

127

Orton, Quaint Rail Remnant

Before the Credit Valley Railway reached Orton, it had few advantages. It languished with a population of a hundred people until the band of wood and steel thrust new life into its sleepy streets in 1879. The sawmill ran on coal, an innovation made possible by the railway. The absence of a grist mill reflected both the lack of water power and the paucity of prosperous farms nearby. Nevertheless, the railway achieved its intended purpose, stimulating a "mini-boom" for the hamlet. For a number of years after 1910, Orton was an excellent example of the ghost towns referred to in the popular literature. Orton is no longer an important railway stop or major service centre, but it offers a pleasant and relatively inexpensive residential retreat in the country. It is also a stop on the Credit Valley Railway Trail.

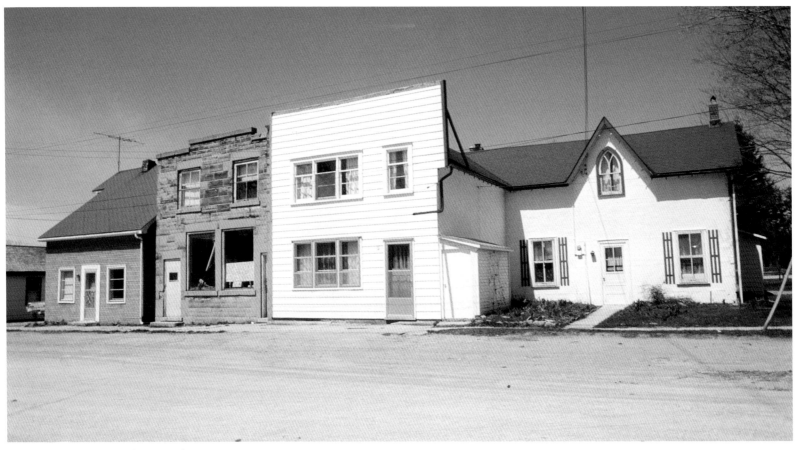

Orton in the 1960s — almost a ghost town.

GHOST TOWNS

Elsewhere in the county we encounter settlements that have all but disappeared. Armstrong Mills just off the Elora Road is nestled in the lush valley of the Speed River, where a thriving community with a blacksmith, mill and general store once stood. All that remains today is the beautifully restored limestone mill and a complex of matching structures by the river. This limestone group graphically illustrates the value of well-constructed heritage buildings converted to modern uses instead of being demolished. Nearby, commuters who prefer the country life occupy newer homes surrounded by lush green manicured grounds.

Armstrong Mills just off the Elora Road is nestled in the lush valley of the Speed River.

Speedside is dominated by a delightful octagonal stone church built for the Congregationalists in 1853.

A few kilometres to the north, Speedside is dominated by a delightful octagonal stone church built for the Congregationalists in 1853. For a number of years it served as the concert hall for the annual Speedside Festival. This event attracted numerous well-known classical musicians from across the country. The wood-panelled interior of the church resounded with strains of Bach and Beethoven, and was crowded with music lovers for several evenings each autumn. Now only the church and a few houses remain to mark the location of a hamlet that once boasted a hotel, general store with post office, shoemaker, weaver, blacksmith and pump maker.

Built by Scottish settlers in Oustic in 1883 and restored in 1974, this is now St. Peter's Roman Catholic Church.

A little farther to the northwest, Oustic is similar, although it possesses a few more homes than Speedside. Crowning its steep drumlin is an elegant stone Gothic church with a soaring spire. Built by Scottish settlers in 1883 and restored in 1974, it is now St. Peter's Roman Catholic Church.

Farewell is a crossroads community in the centre of Mennonite farming country some 10 kilometres (6¼ mi.) south of Mount Forest. Its simple, white Mennonite church, school and ball field are its most distinguishing characteristics.

Macton is marked by St. Joseph's Catholic Church (1878) and the former Connolly home, built in 1880.

Homes have impressive woodpiles in Farewell, a Mennonite community.

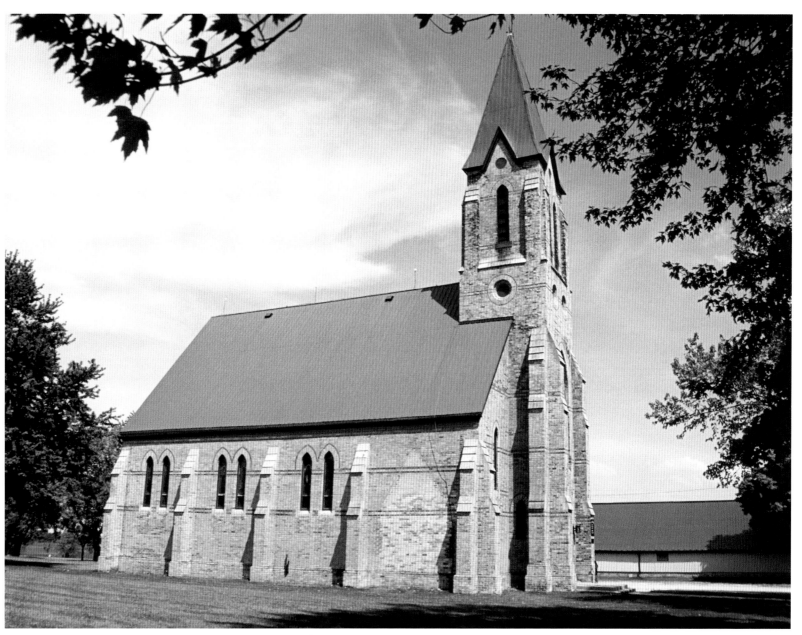

Macton is marked by St. Joseph's Catholic Church (1878).

Arts and Artisans in Wellington County

WELLINGTON COUNTY IS HOME TO a remarkable number of professional artists and artisans. Guelph, Elora, Fergus and other smaller communities frequently feature studio tours and open house events. Exhibits vary from creations by silk painters, glass-blowers, photographers, sculptors, ironmongers and potters, to those by artists using acrylic, oil, watercolour, pastels and charcoal. During the October Art Show and Sale, almost 50 visual artists display their talents in and around downtown Guelph. Included are Marlene Jofriet's acrylic and watercolour paintings, photographs by Ross Davidson-Pilon and prints by Tammy Ratcliff. Other artists such as Goldie Sherman the potter, Carolyn Riddell the painter and Dean Palmer the photographer are well known and respected. It is impossible to enumerate even a representative sample of local artists.

Ken Danby

Ken Danby was the most famous among the artists who live and work around Guelph. In his studio north of the city, he created exciting images in oils, acrylics, watercolours and serigraphs that have been displayed to critical acclaim around the world. Ken Danby's work has been the subject of several popular books and he is listed in numerous reference publications such as *Who's Who in Canada, Who's*

Guelph Carousel, Ken Danby

Who in American Art, The Canadian Encyclopedia, and *Contemporary Artists*.

His originals are in many institutional collections including the National Gallery of Canada, the Montreal Museum of Fine Art, the Museum of Modern Art, the Brooklyn Museum, the Art Institute of Chicago, several other international galleries and numerous private collections. He was an elected member of the Royal Canadian Academy of Arts and received multiple awards, as well as the prestigious Order of Ontario and Order of Canada.

Ken Danby was also active in local planning and fundraising. In 1977, during Guelph's sesquicentennial celebrations, he created a special watercolour painting for the

Ken Danby

city, featuring the historic carousel in Riverside Park. The following year he organized a fundraising drive to save the carousel from demolition and assisted in refurbishing it for the park, where it continues to be a major attraction. In 1992 he led a major three-year battle against a proposed mega-dumpsite that would pollute the Speed River. Eventually, geologists confirmed that the location was unsuitable and the proposal was stopped. During his 40 years as a resident of Wellington County, Ken Danby contributed significantly as both an outstanding artist and a concerned citizen of his community. Unfortunately, Ken Danby died suddenly in 2007.

The Guelph Googenheim Gallery

At 129B Woolwich Street, near the bottom of a narrow lane extending from Woolwich to the Speed River, we discover the Guelph Googenheim. It is the showroom and workshop of two delightful and accomplished artists: Hock Wee and Tiffany Horrocks. Their lives and artistic creations are now closely interlinked, but this was not always so.

Hock Wee was born and raised in Singapore where he was employed by his father and became an expert woodworker. In 1983 he moved to Canada to study mathematics at the University of Waterloo, but soon became involved in construction. Hock's excellent craftsmanship caught the attention of others who began to commission him to design and build cabinets and furniture. Eventually his creations attracted the interest of artisans who encouraged him to experiment with clay and pottery. This led to potters' courses in Waterloo where he learned the fine points of raku and other ceramic techniques.

Hock Wee became a full-time potter, sculptor and stonemason in 1995 when he opened the Googenheim Gallery. His superb raku sculptures and other clay creations have become widely known and very popular. Today, however, Hock is not alone in the studio. Tiffany Horrocks now shares the space and has become an excellent sculptor in her own right.

Tiffany moved from Kincardine to Guelph in 1994 where she met Hock Wee. Having a keen interest in art and especially ceramics, she asked Hock to teach her as an apprentice. His first answer was, "I work alone." Despite this negative reaction, Tiffany persisted and convinced Hock to become her mentor during a three-year apprenticeship. She learned well and has become an accomplished sculptor and raku artist. Since then they have worked together, collaborating and creating individual sculptures.

Today the Guelph Googenheim is renowned for the excellence of its art and the talent of its owners. Its magnificent, large-scale, raku ceramic figure abstracts sell locally and as far afield as Toronto, New York and abroad. Hock's sculptures are displayed in the Burlington Cultural Centre and in the permanent collection of the Art Gallery of Ontario. The Guelph Googenheim provides a friendly, creative oasis in downtown Guelph, and has become an important addition to the local arts community. It is open for visits by appointment and frequently exhibits shows by guest artists.

The Guelph Googenheim Studio.

Hock Wee and Tiffany Horrocks at the Guelph Googenheim.

Stonehouse Pottery

Jessica Steinhäuser is a talented, vibrant and enthusiastic artist whose studio at 128 Woolwich Street is crammed with fascinating creations. Jessica was born in Canada but spent much of her youth in Germany. Her formal artistic training began at the State School for Art and Design in Nürnberg where she took a practicum in pottery for a year. She then spent three years at the State School for Ceramics in Landshut from which she received her designation as a Graduate Journeyman Potter.

In 1988 Jessica emigrated to Canada to become a professional potter. After working in a shared pottery studio and selling her wares at the Guelph Farmers' Market for a year, she opened Stonehouse Pottery. Her whimsical artistic creations range from porcelain, stoneware and earthenware dishes to ceramic murals, acrylic paintings and the building of *Kachelofens*, traditional European heaters. In her art she combines the rigour and discipline of German craftsmanship with the open spaciousness of the Canadian countryside. Whenever possible she incorporates romantic European towers and turrets into her art.

Jessica's lifelong dream, which is just now being realized, is the creation of *Kachelofens* in her studio. These handsome, intricately designed clay ovens radiate heat for a whole day from the combustion of three small logs. Widely used in Europe since the 1500s, the *Kachelofen* is a decorative, energy-efficient, environmentally friendly heater that can also be an exquisite piece of art. Today a prototype designed and built by Jessica stands in her studio. Given the recent interest in climate change and our concern for energy efficiency, the time is ripe for the introduction of the *Kachelofen* into North America. Jessica's lifelong dream will be realized and *Kachelofens* will be acquired for heating and energy conservation in Canada.

Jessica's other activities include being the founder of the Guelph Potters' Market at the Goldie Mill where sixty potters display their wares for two days each summer. A ceramic installation in the Lower Foyer of the Guelph Youth Music Centre, was commissioned for the Where Music Begins campaign. Her creations have become part of many private collections and she has exhibited widely. In 1999 she was the featured artist at the Canadian Clay and Glass Museum in Waterloo. A visit to Stonehouse Pottery is a joy, both because of its charming, enthusiastic owner and because of the superb creations therein.

Jessica Steinhäuser, a Guelph potter.

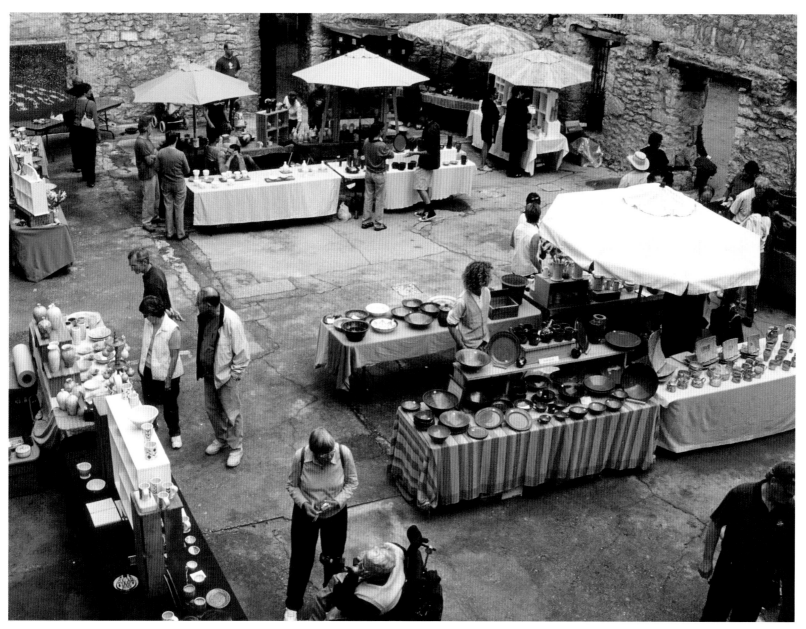

Guelph Potters' Market at the Goldie Mill, where sixty potters display their wares for two days each summer.

The Macdonald Stewart Art Centre

The Macdonald Stewart Art Centre, beside the University of Guelph on Gordon Street, has become the County's premier art gallery. In 1975 a naming grant by the Macdonald Stewart Foundation enabled the city, the university, the county and the Upper Grand School Board to convert the former Macdonald Consolidated School into a modern art gallery. The handsome red-brick building was renovated to international standards and modified to contain seven galleries on three floors.

In 1983 the Donald Forster Sculpture Park was established to honour a former university president, and now contains over 25 works. Its 1-hectare ($2\frac{1}{2}$-acre) site next to the Art Centre displays sculptures by artists from across the country, including historical works by Frances Loring and Florence Wyle, and the popular Begging Bear by Carl Skelton. Many of the pieces are the first public works of exhibiting artists.

The Art Centre is renowned for its outstanding selection of Canadiana, including Inuit art and works by the Group of Seven. Its 6,000 pieces include a contemporary Canadian silver collection and over 700 drawings, textiles and rare print stones from the Canadian Arctic. Each year the Centre organizes exhibitions that tour across Canada and abroad, accompanied by written documentation of the artists and their work. It is also well known for its numerous publications and catalogues.

The Macdonald Stewart Art Centre.

Judith Nasby, curator and director.

The Macdonald Stewart Art Centre is renowned for its selection of Canadiana, Inuit art and works by the Group of Seven.

In 1975 Judith Nasby moved from being director of the University Gallery to develop the Macdonald Stewart Art Centre. Since then, she has been curator for numerous exhibitions, and written and lectured extensively. She has been a distinguished visiting international scholar at several institutions in the United States and China and is an adjunct professor in the university's School of Fine Arts. Much of the success of the Macdonald Stewart Art Centre is a direct result of Judith Nasby's imagination, talent and toil as curator and director.

The Arts Across the County

The annual Hills of Erin Studio Tour and similar events feature galleries and studios displaying a profusion of artistic talent. Driving through the colourful, rolling autumn countryside between the studios is almost as satisfying as visiting the varied exhibits. Every September artists and artisans. such as quilter Chris Tuck, weaver Clare Booker, and sculptor Monica O'Halloran-Schut open their workshops for this fascinating event. The Elora-Fergus Studio Tour in September and October features 23 artists such as glass-blowers Tim and Katherine McManus, batik artist Linda Risacher Copp, and collage artist Joel Masewich. Because there are far too many outstanding artists and artisans in Wellington to describe even a representative sample, two are profiled to illustrate the exceptional talent in the county.

Paul Morin is one of Wellington's most prolific and internationally recognized artists. His studio, where he creates multimedia art, CDs and videos, is nestled in the woods by the 15th Sideroad of Erin Township. Many of the

On the Hills of Erin Studio Tour.

Paul Morin in his Kiva.

Starlodge, Paul Morin.

Skywater, Paul Morin.

books that he illustrates are distributed worldwide, including *The Orphan Boy*, for which he received the Governor-General's Award, just one of his 25 national and international honours.

Africa became very important to Paul when his parents moved to Guinea, West Africa, where his father trained personnel to run a railroad. His visits there greatly influenced his art, which began to embrace images of Third World peoples and their mythology. Their visions, spirituality and nature provide inspiration and permeate his art. Research for book illustrations and other creations has led Paul to visit Africa, China, South America, Central America and Australia.

Paul's art has been exhibited in galleries and museums across the country, including the prestigious Museum of Civilization in Ottawa. He is noted for his outstanding use of colour, varied media and texture. His paintings portray everything from Aboriginals in Australia to people and animals in Africa. His interpretations of snow, water and trees, and dazzling abstract images display intense and vivid colours. An excellent selection was exhibited during Paul's show "The Light Within," in the fall of 2005 at the Wellington County Museum and Archives near Elora. The Burdette Gallery and his own gallery on Main Street in Rockwood display a selection of his creations.

Despite his enormous success and wide recognition, Paul Morin is approachable, personable and enthusiastic. A visit to his studio includes not only insight into his art, but also stimulating discussions about everything from folk music to anthropology. He has accurately captured the essence of the diverse societies that he depicts, and projects it effectively through creations ranging from tiny pictures to enormous installations. A visit with Paul Morin is an exciting and educational experience, yielding rewarding insights into his art, character and philosophy.

Rosalinde Baumgartner's studio is beside her home at 5949 Wellington Road 26, near Belwood. There, she creates etchings, monoprints, watercolours, charcoal drawings and oil paintings. Rosalinde has won awards in juried exhibitions across southern Ontario and Toronto. Her pieces have been exhibited in the Macdonald Stewart Art Centre in Guelph, The Art Gallery of Mississauga, Toronto Art Expo and in several county museums. Recently she participated in an exhibition entitled "12 Artists from Canada" to commemorate the 700th anniversary of her native Switzerland.

Rosalinde is an Honours graduate of the Fine Art program at the University of Guelph and subsequently has taken additional courses in printmaking. Her eclectic prints have been used as illustrations for books and have been exhibited in a number of galleries. Rosalinde's glowing colours, careful design, light and shadow produce compositions of enormous complexity. They range from lifelike portraits to dazzling scenes of the countryside. Her studio abounds with a myriad of multifaceted art, reflecting her skill as an artist and printmaker. Delicate life studies mingle with lovely landscapes and etchings. Rosalinde is a gracious and friendly host who welcomes visitors with warmth and enthusiasm.

It is possible to devote many delightful hours to exploring the arts in Wellington's towns and countryside. Workshops, juried shows and studio tours occur frequently, each exhibiting exquisite examples of the art of Wellington County.

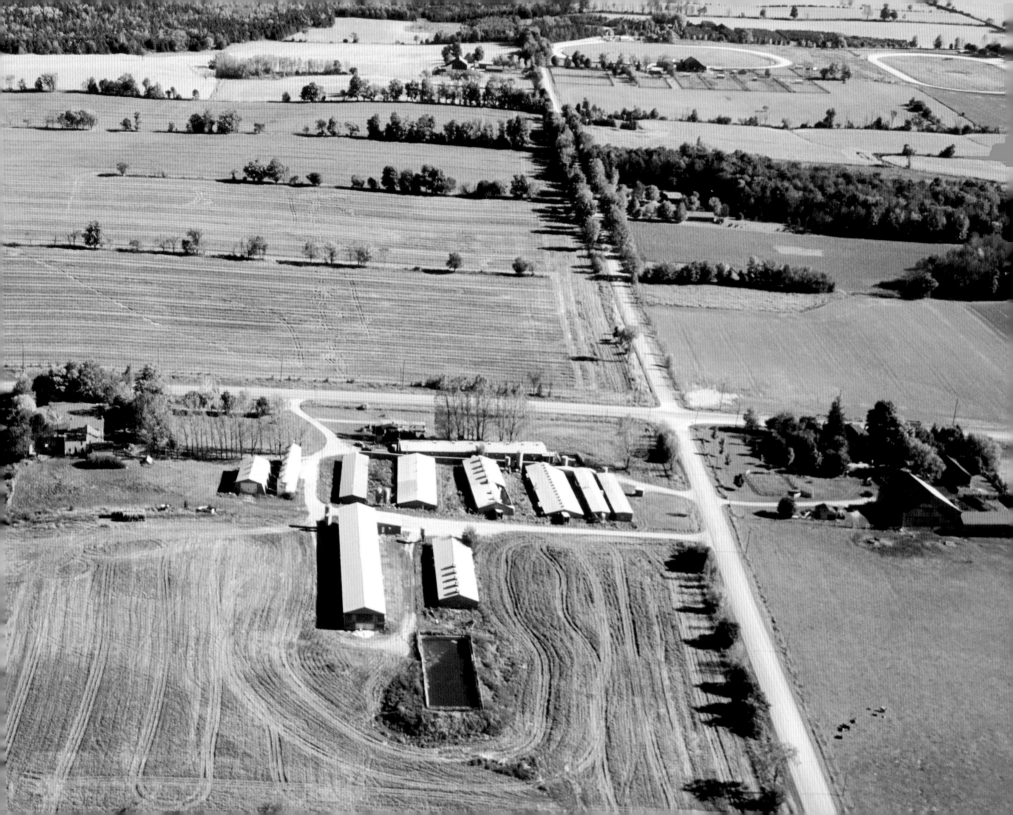

Towards a Sustainable Future

WELLINGTON COUNTY IS A MULTIFACETED mosaic of town and country, farm and forest, wilderness and water. Its conservation areas, lakes and trails preserve pristine characteristics from the past. Luther Marsh is an ecological oasis. The valleys of the Speed and Eramosa rivers offer bucolic solace, even in the heart of Guelph. Smaller places like Elora, Fergus and Mount Forest are gems. Historic business blocks grace the main streets of Harriston and Erin. Other towns and villages offer spacious subdivisions to people retiring from the farm or city. Crossroads hamlets and villages preserve the past in their former hotels and general stores. Artists such as Ken Danby, Rosalinde Baumgartner and Paul Morin have established their studios on quiet byways in the countryside. Nearby, commuters live in bungalows or in rambling mansions on their hobby farms.

In rural Wellington County, 40-hectare (100-acre) farms compete for space with enormous feedlots, vast poultry producers and extensive soybean operations. Nevertheless, Donald and Joyce Blyth continue the family's traditions on their 54-hectare (134-acre) century farm. Peter Hannam's First Line Feeds typifies the agribusiness that dominates the rural economy. Part-time farmers Marcia and John Stevers remain to sustain our rural heritage and the agrarian look of the land. Specialty operations such as Cox Creek Cellars and Schatti's Eramosa Elk Enterprises contribute delicious wine, elk meat and variety to the economy. Agriculture remains paramount in the countryside, but all is not well.

Large-scale commercial agriculture in Wellington County.

Rural Problems and Possibilities

Many agricultural areas in Wellington County face increasing demands for land to accommodate factories, homes and businesses. Sprawling estate subdivisions have proliferated in places as disparate as Puslinch Township, Erin Township, Belwood and Hillsburgh. They consume arable land, increase the nonfarm population and create pressure for urban services in rural areas. Recent residents may object to noise and odours generated by farm neighbours who have lived there for years. In some townships, zoning prevents farmers from selling to developers, thus depriving them of a comfortable retirement fund. Population growth and economic development continue to exacerbate these conflicts.

High-density townhouse developments in Southern Guelph.

Farming has become economically risky. When commodity prices drop, marginal farmers who have invested heavily in feed, equipment and fertilizer may face bankruptcy. Recent bovine spongiform encephalopathy (mad cow disease) scares have reduced prices for beef cattle, while the bottom has dropped out of the market for elk. Income from soybeans and grain corn fluctuates wildly. During 2005 many commodity prices were at an all-time low. When the costs of seed, feed and machinery become greater than their profits, even the largest operators experience financial hardship.

Many rural traditions are being threatened by agribusinesses. When former 40-hectare (100-acre) farms are consolidated into 400-hectare (1,000-acre) businesses, rural populations decrease and traditional farm buildings are

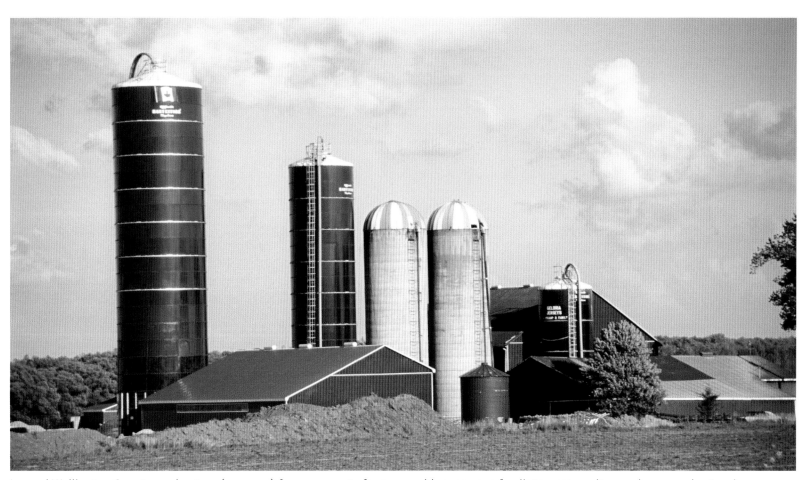

In rural Wellington County, 40-hectare (100-acre) farms compete for space with enormous feedlots, vast poultry producers and extensive soybean operations.

demolished. The scale and expense of agribusiness make it difficult for small farmers to compete. Prospective operators who wish to produce milk or poultry must purchase expensive quotas from supply management boards or from retiring farmers. Increasing land prices and farming start-up costs are prohibitive for all but the wealthy. Unpredictable weather and fluctuating markets for hogs, chickens, beef and soybeans make farming a precarious occupation for everyone.

Runoff from pesticides and chemical fertilizers kill fish and alter the ecology of once-pristine lakes and streams. Algae nourished by chemicals in some water bodies make them unfit for recreation and aquatic life. Every summer beaches in Wellington's conservation areas are closed because of pollution. Vast quantities of liquid manure from hog farms have the potential to pollute groundwater and have to be treated with care. We must plan carefully to preserve our rural countryside.

Some Urban Challenges

First and foremost among urban concerns is population growth, especially in Guelph, Elora, Rockwood, Erin and Fergus. Ontario's *Places to Grow* legislation has decreed that central Guelph and parts of Wellington County must absorb some of the massive influx of population expected in the next 25 years. Immigration will escalate pressure on these communities to increase their housing stock, road capacities, social services, sewage treatment facilities and water supplies.

Guelph's galloping growth during the last ten years is a sad reflection of this situation. Its suburbs now sprawl to the east, west and south, threatening to overwhelm the charming small town atmosphere that initially attracted its residents. The city is facing increasing traffic and congestion. Its social services are overwhelmed. There is a strong possibility that Guelph's wells can no longer satisfy increasing demands for water. There are questions about the ability of the Speed River to accommodate additional sewage effluent. Now that its landfill has closed, how should Guelph's garbage be managed?

Despite its obvious charm, Elora also faces some difficult challenges. On sunny summer afternoons, the crush of visitors is oppressive. Buses and cars jam Mill Street, making access almost impossible. Elora is in danger of being spoiled by its own success. More businesses, tourists and residents have the potential to transform it from a delightful country town into a tourist trap. Some recent local elections have been fought on the "growth versus no-growth" issue. The establishment of a racetrack, complete with a gambling casino, on the edge of town has increased traffic and the costs of services.

Rockwood has sewage capacity problems, but continues to attract residents who commute to the Greater Toronto Area. Commercial and industrial development in Fergus has increased rapidly, threatening the annexation of additional productive farmland. The situation is less acute in places like Clifford, Harriston, Palmerston and Mount Forest where ample land is available and potable water is more abundant than in the south. Nevertheless, despite vigorous protests from citizens and environmentalists, municipal councils seem determined to promote growth, whatever the consequences. Politicians work hard to attract additional development in order to increase the tax base but do not always critically examine the environmental consequences and economic costs of such actions.

Large areas of the county are controlled by conservation authorities dedicated to preserving the environment and providing recreational resources.

Some Solutions

So what does the future hold for Wellington County? Will there be more congested roads, increasing urban sprawl and shortages of water? Will shopping centres, factories and subdivisions continue to creep across the land? Will the quality of life decrease for everyone in the county? Or can we expect carefully controlled urban growth and the preservation of our precious environment? The pendulum could swing either way.

Ontario's *Planning Act* controls growth and planning in the province. At the municipal level, *Official Plans* and zoning bylaws regulate development. Most communities employ competent planners and engineers to advise on policy, but in the end, decision-making and planning approvals are the prerogative of elected councillors. The Ontario Municipal Board is the ultimate arbiter of disputes about development. Unfortunately, excellent advice from planners and the public is often ignored by councils and by the OMB.

Is there a bright side? Fortunately, the answer is yes. Large areas of the county are controlled by conservation authorities dedicated to preserving the environment and providing recreational resources. Areas such as the Luther Marsh and Guelph Lake will continue to be protected for the public. A major proportion of rural nonfarm development has occurred on moraines or drumlins that will never support viable agriculture.

Many rural communities have large areas within their boundaries that can be developed. The creation of amalgamated municipalities during the late 1990s means that planning will occur at a regional rather than local scale. The compact development mandated by *Places to Grow* will go a long way towards alleviating problems in our larger urban areas. Higher

Wellington's beauty can be preserved if concerned citizens continue to participate in its planning.

residential densities will facilitate public transit and walking to places of work, recreation and shopping. Governments can enforce sections in *Official Plans* that encourage compact residential suburbs. Zoning bylaws can be crafted to encourage mixed, higher density development. Guelph is still a viable and extremely attractive city that can be improved. Most of our smaller communities retain their rural charm.

Rural Wellington County remains primarily agrarian and picturesque, with neat farmsteads and substantial homes flanking its roads. Where land is rolling, swampy or rocky, scenic areas abound. Most traditional farmers and owners of agribusinesses are excellent stewards of the land. Enforcement of regulations affecting runoff from fertilizer and pesticides has improved. People such as the Schattis, the Blyths and the Stevers have maintained much of the "rural idyll" of popular literature. Their properties are carefully maintained and their land is being conserved for future generations.

The citizens of Wellington County have the power to determine its fate. The people who opposed the casino in Elora are ready for another issue. Those who worked with Ken Danby to halt the ill-conceived landfill are ready to spring into action. Similar committees exist in a number of other communities. The best recent example of effective citizen participation is that of the Guelph Civic League, founded by James Gordon. After four years of rampant growth and questionable decisions by council, the group was formed to influence the next election. It motivated thousands to vote for progressive politicians supporting controlled growth and responsible planning. As a result, a new council that values citizen participation and heeds expert advice was elected. Ordinary people can and must be involved to secure a sustainable future for Wellington County.

A drive through the countryside passes historic centennial farmsteads, attractive residential estates, fields of corn or soy and thriving urban communities. Some farms display long, low, buildings set in sweeping open landscapes providing panoramic vistas across their extensive fields. Others continue to consist of a barn, a house and 40 hectares (100 acres) of land with fences and a woodlot at the rear. During the long and colourful history of Wellington County, people and nature have combined to create endless variety and abundant beauty along its picturesque byways. This beauty can be preserved and the future can be secured if concerned citizens in the county continue to participate in its planning.

Wellington County's small-town atmosphere, riverside sites and parks attract families from Kitchener, Waterloo, Guelph and even Toronto.

Administrative Boundaries of Wellington County

- In 1788 Lord Dorchester established first political division incorporating territory that became Wellington County. It straddled Upper Canada Districts of Nassau and Hesse, whose boundary traversed the centre of the area that ultimately included Wellington County.
- In 1838 Wellington County became a separate entity named for the Duke of Wellington. Guelph chosen as county seat.
- On February 8, 1842 first session of Wellington District Council held in the new Guelph Court House at 74 Woolwich Street.
- By 1849 Wellington District much larger than the county today. Included all of today's Wellington, Waterloo and Grey Counties, and a portion of what became Dufferin County.
- In 1849 Wellington's first council replaced by Waterloo County Council.
- On January 23, 1854, Wellington County Council created to administer the twelve townships that comprised Wellington County until 1996.
- In 1996 Wellington's twenty-two municipalities amalgamated into eight.

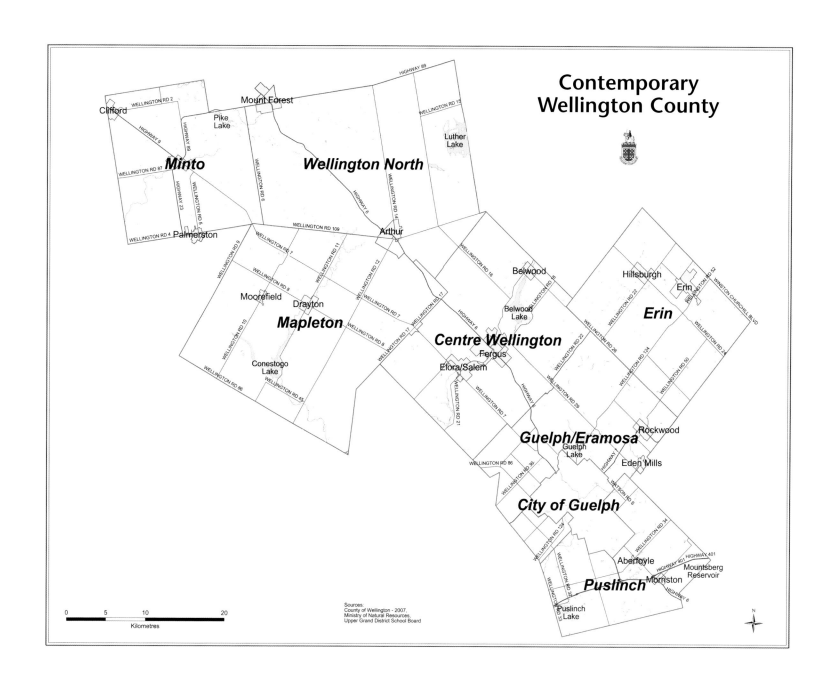

Contemporary Wellington County

Sources:
County of Wellington - 2007,
Ministry of Natural Resources,
Upper Grand District School Board

155

Bibliography

Byerly, A. E. *The Beginning of Things in Wellington and Waterloo Counties*. Guelph: Guelph Publishing, 1935.

Centennial History: 1842–1967: Erin Township and Erin Village. Erin, Ontario: 1967.

Chapman, L. J., and D.F. Putnam. *The Physiography of Southern Ontario*. Reprint, Toronto: University of Toronto Press, 1986.

Connon, J. R. Elora. Elora, Ontario: Elora Express and News Record, 1930.

———. *Early History of Elora, Ontario and Vicinity: 1862–1931*. Reissued with an introduction by Gerald Noonan. Waterloo: Wilfred Laurier Press, 1975.

County of Wellington. *Centennial, 1854–1954*. Fergus, Ontario: Fergus News-Record Print, 1954.

Dahms, F. A. "How Ontario's Guelph District Developed." *Canadian Geographical Journal* 94 (1977): 48–55.

———. *The Heart of the Country — From the Great Lakes to the Atlantic Coast: Rediscovering the Towns and Countryside of Canada*. Toronto: Deneau, 1988.

———. "The Evolving Spatial Organization of Settlements in the Countryside — An Ontario Example." *Tidjschrift voor Econ. en Soc. Geografie* 71 (1980): 295–306.

———. "Small Town and Village Ontario." *Ontario Geography* 7/8 (1980): 19–32.

———. "The Evolution of Settlement Systems: A Canadian Example, 1851–1970." *Journal of Urban History* 7 (1980): 169–204.

———. "'Demetropolitanization' or the 'Urbanization' of the Countryside? The Changing Functions of Small Rural Settlements in Ontario." *Ontario Geography* 24 (1984): 35–61.

———. "Residential and Commercial Renaissance: Another Look at Small Town Ontario." *Small Town* 17 (1986): 10–15.

———. *Beautiful Ontario Towns*. Toronto: Lorimer, 2001.

———. "The Growth and Planning of Guelph in the 20th Century." In *Guelph: Perspectives on a Century of Change 1900–2000*, edited by D. Matheson and R. Anderson, 221–264. Guelph: Guelph Historical Society, Ampersand Press, 2001.

———. *Picturesque Ontario Towns*. Toronto: Lorimer, 2003.

Day, Frank. *Here and There in Eramosa: An Historical Sketch of the Early Years, and of the People and Events Contributing to the Growth and Development of the Township*. Guelph: Leaman Print. Co., 1953.

Davidson, Joseph M., and Everon Flath. *History of the Village of Drayton*. Drayton, Ontario: 1957.

Denison, Jean. *Main Street: A Pictorial History of Erin Village*. Cheltenham, Ontario: Boston Mills Press, 1980.

Drayton Centennial Book Committee. *Drayton's Historic Album 1875–1975*. Drayton Ontario: J. Akkerhuis, 1975.

Edwards, William J. *Mount Forest: The Way We Were*. Cheltenham, Ontario: The Boston Mills Press, 1979.

Ferrier, A. D. *Reminiscences of Canada and the Early Days of Fergus*. Fergus, Ontario: Fergus News Record, 1923.

Guedalla, Philip. *Palmerston, 1784–1865, 1889–1927*. New York: Putnam, 1927.

Guillet, E. C. *Early Life in Upper Canada*. Toronto: The Ontario Publishing Co., 1933.

Harris, R. C., and J. Warkentin. *Canada Before Confederation*. Toronto: Oxford University Press, 1974.

Hewitt, Kenneth. *Elora Gorge: A Visitor's Guide*. Toronto: Stoddart, 1995.

Hilts, Don, and George Day. *Rockwood 1929–1982*. Rockwood, Ontario: 1982.

Historical Atlas of the County of Wellington, Ontario. Toronto: Historical Atlas Publishing Co., 1906.

Historical Atlas of Waterloo and Wellington County. Toronto: Walker and Miles, 1877.

Hoffman, D. W., and H. F. Noble. *Acreages of Soil Capability Classes for Agriculture in Ontario*. ARDA Report No. 8, Ottawa: 1975.

Hutchinson, Jean F. *History of Wellington County*. Grand Valley, Ontario: Landsborough Print, 1998.

Keddie, P. D., and J. A. Mage. "Agriculture in Ontario." In *Ontario: Geographical Perspectives on Economy and Environment*, edited by B. Mitchell, 101–125. Geography Publication No. 34. Waterloo: University of Waterloo, 1990.

Keddie, P. D., and J. Wandell. 'The Second Wave': The Expansion of Soybeans Across Southern Ontario, 1951-96." *The Great Lakes Geographer* 8 (2001): 15–30.

Kortland, Patricia. *Hillsburgh's Heyday 1938*. Erin, Ontario: Boston Mills Press, c.1983.

Kunert, M., M. Conigilo, and E. C. Jowett. "Controls and Age of Cavernous Porosity in Middle Silurian Dolomite, Southern Ontario." *Canadian Journal of Earth Science* 35 (1998): 1044–1053.

Mack, Hazel. *History of Eden Mills and Vicinity*. Rockwood, Ontario: Sponsored by Eden Crest Women's Institute and Eden Mills Women's Institute, 1954.

Mack, Hazel L. (Spencer). *Twelve Townships of Wellington County*. Guelph: Ampersand Press, 1977.

———. *Historical Highlights of Wellington County: Series No. 1*. Acton, Ontario: Dills Printing & Publishing, 1955.

———. *Historical Highlights of Wellington County: Series No. 2*. Guelph: Royal Women's Institute, 1956.

Mage, J. A., and S. Fletcher. *Recent Migration of Mennonite Farmers into the Mt. Forest Area of Ontario, Phase 1: Location and General Land Use Characteristics*. Occasional Paper No. 13. Guelph: Department of Geography, University of Guelph, 1989.

Maryborough Historical Book Committee. *Through the Years: Maryborough Township 1851–1998*, vol. 2. Maryborough: 2000.

McMillan, C. J. *Early History of the Township of Erin*. Cheltenham, Ontario: The Boston Mills Press, 1974.

McKenzie, W. F. "Arthur Village." Guelph: Guelph Daily Mercury, April 25,1908.

Miller, Robert J., *The Stone Buildings of Guelph: A Geographical Study*. Senior Paper (CA2ON UG65 70M34). Guelph: Department of Geography, University of Guelph, 1970.

Mitchell, C., and F. Dahms, eds. *Challenge and Opportunity: Managing Change in Canadian Towns and Villages*. Publication No. 48. Waterloo: Department of Geography, University of Waterloo, 1997.

Morrow, R. *Fergus and Elora: A Comparison*. Hamilton, Ontario: 1964.

Morgan, A. "Glacial Potholes." *Grand Strategy Newsletter* 7, no. 4 (May/June 2002): 1–3. http://www.grandriver.ca/Grand Strategy/pdf/ga_may02.pdf. (accessed August 21, 2007).

Murray, David R. *Hatching the Cowbird's Egg: The Creation of the University of Guelph*. Guelph: University of Guelph, 1989.

O'Donnell, Paul, and Frank D. Coffrey, eds. *Portrait: A History of the Arthur Area*. Arthur, Ontario: Municipality of Arthur, 1971.

Peel History Committee. *Portraits of Peel: Attiwandaronk to Mapleton*, 1999. Acton, Ontario: The Free Press, 1967.

Puslinch Ontario Township Council Historical Committee. *Annals of Puslinch 1850–1950*. Acton, Ontario: The Free Press, 1950.

Puslinch Ontario Township Council Historical Committee. *Annals of Puslinch 1950–1967*. Acton, Ontario: The Free Press, 1950.

Reaman, G. E. *A History of Agriculture in Ontario*. 2 vols. Toronto: Saunders, 1970.

Ross, Alexander, M. *The College on the Hill: A History of the Ontario Agricultural College 1874–1974*. Toronto: Copp-Clark Publishing, 1974.

Spelt, J. *Urban Development in South-Central Ontario*. 2nd ed. Toronto: McClelland and Stewart, 1983.

Taylor, G. M. *Historical Sketches of Clifford 1855 to 1967*. Harriston, Ontario: The Harriston Review, 1967

Templin, Hugh Charles. *Fergus: The Story of a Little Town*. Fergus, Ontario: Fergus News-Record, 1933.

———. *A Brief History of Wellington County*. Fergus, Ontario: Fergus News-Record, 1946.

Trask, Norma. *Our History: The History of Alma and District*. nd.

Tuck, Judy. *History of Harriston: A Commemorative Book for the Harriston Centennial July 1–8, 1978*. Harriston, Ontario: Harriston Historical Publication Committee, 1978.

United States Department Of Agriculture. *Farmers in a Changing World*. Washington: Government Printing Office, 1940.

Waterston E., and D. Hoffman. *On Middle Ground: Landscape and Life in Wellington County, 1841–1891*. Guelph: University of Guelph, 1974.

Wellington County Historical Society. *Wellington County History, 1854–2004*. County of Wellington 150th Anniversary, vol. 17, 2004. (Walking Tours of Wellington Communities)

Wood, J. D., ed. *Perspectives on Landscape and Settlement in Nineteenth Century Ontario*. Toronto: McClelland and Stewart, 1975.

Wright, Arthur Walker, ed. *Pioneer Days in Nichol, including Notes and Letters Referring to the Early Settlement of the Township of Nichol, Fergus, Elora and Salem*. Mount Forest, Ontario: 1924.

———. *Memories of Mount Forest and Surrounding Townships: Minto, Arthur, West Luther, Normanby, Egremont, Proton, in Honor of the Diamond Jubilee of the Confederation of the Dominion*. Mount Forest, Ontario: The Confederate, 1928.

Wellington County Council. *Centennial 1854–1954: the County of Wellington*. Fergus, Ontario: Fergus News-Record, 1954.

Index